STILL
WAR

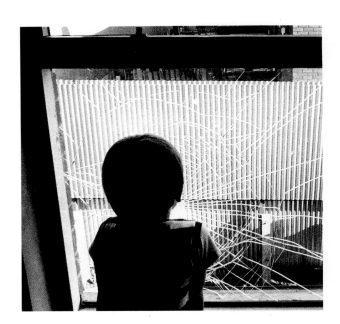

The idea that those who are most happily at home in the modern world . . . may be the most vulnerable to the demons that haunt it; the idea that the daily routine of playgrounds and bicycles, of coping and eating and cleaning up, of ordinary hugs and kisses, may be not only infinitely joyous and beautiful but also infinitely precarious and fragile; that it may take desperate and heroic struggles to sustain this life, and sometimes we lose.

Marshall Berman, **All That is Solid Melts into Air**

STILL WAR

PHOTOGRAPHS FROM THE NORTH OF IRELAND
By Mike Abrahams and Laurie Sparham

Editor Trisha Ziff
Co-editor/designer David Fox
Foreword by Colin Jacobson
Introduction by Bernadette McAliskey
Essay by Sorj Chalandon

BELLEW PUBLISHING
London

First published in Great Britain in 1989 by
Bellew Publishing Company Limited
7 Southampton Place, London WC1A 2DR

Photographs copyright © Mike Abrahams & Laurie Sparham
Text copyright © Trisha Ziff, Colin Jacobson, Bernadette McAliskey,
Sorj Chalandon

ISBN 0 947792 25 2

Printed and bound in Hong Kong by
Regent Publishing Services Ltd

CONTENTS

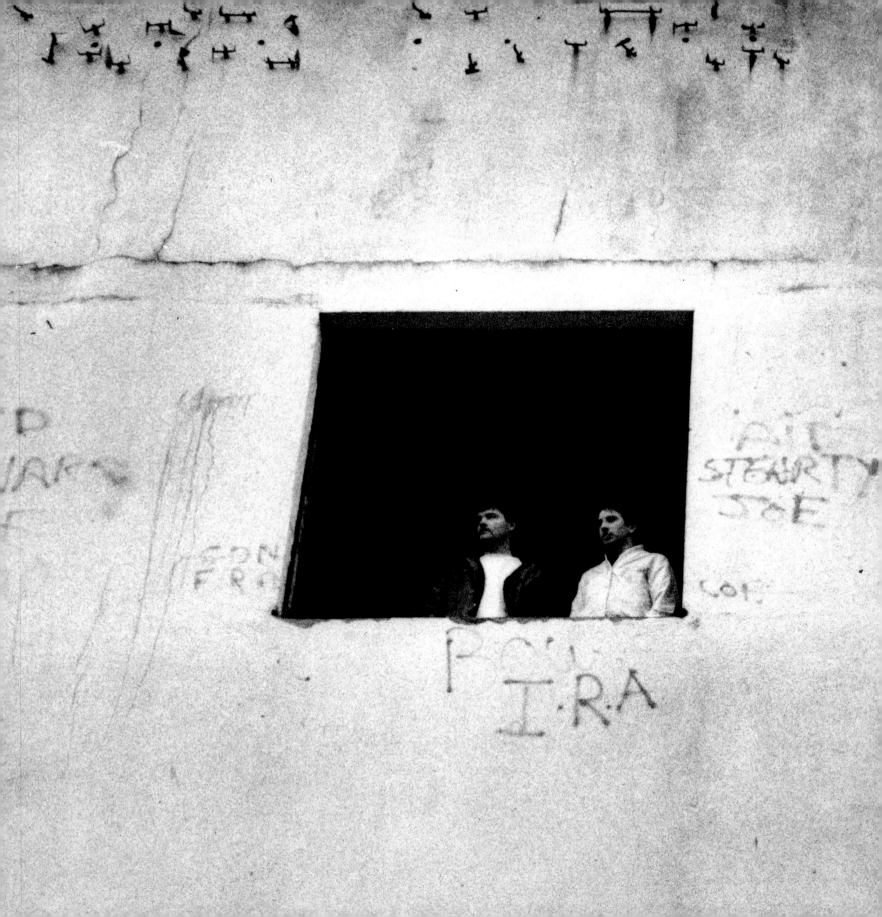

ACKNOWLEDGEMENTS

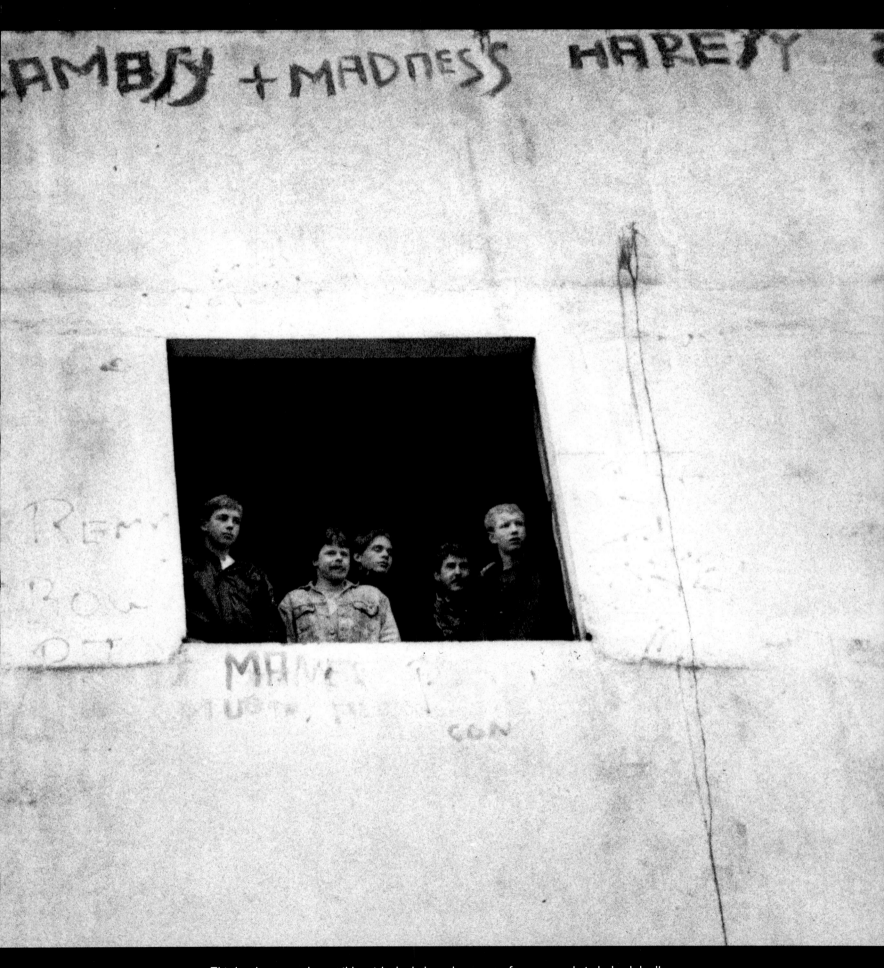

This book was made possible with the help and support of many people in Ireland: Joelle and Tom, Danny, Julie, Jack, Mitchel, Rita, Mr and Mrs Kerr, Kieran, Hawks, Mrs McCracken, Chris. We would like to thank Pat Harper for her research work and for putting together the chronology. Other people who gave us their time, opinions and support include: Ib Bellew, Sorj Chalandon, Liz Curtis, David Elliott, Pete Hammarling, Colin Jacobson, Michael Kauffman, Barry Lane, Bernadette McAliskey, Pedro Meyer, Grazia Neri, Robert Pledge, Judith Rayner, Tony Roberts, Marian Shwart and Sylvia Stevens. For the use of their facilities, we would like to thank Network Photographers and Faction Films. We would also like to thank the Arts Council of Great Britain for their financial support.

Publisher's Acknowledgements

The publisher and authors wish to thank the following
for permission to reproduce extracts:

Marshall Berman, *All That is Solid Melts into Air*, Verso;
John Conroy, *War as a Way of Life, a Belfast Diary*,
William Heinemann Ltd; Eamonn McCann, *War and an Irish Town*,
Penguin Books;Bobby Sands, *Skylark Sing Your Lonely Song*,
Mercier Press.

A long time ago in the scatty sixties, when sociology had not become a dirty word, I stumbled across the concept of 'reification'. This was said to describe a situation in which social relationships seemed to be part of a natural order of things, and therefore largely beyond human control. In this scenario, other people cease to be seen as human and become objects or symbols. I remember thinking at the time, with a staggering lack of originality, that this could explain how it was that human beings can slaughter and oppress each other in huge numbers without any apparent discomfort or distress. After all, objects have no rights or feelings.

Today, in the hard-nosed eighties, such an approach could prove extremely comforting to the troubled liberal conscience. We seem to meet the disadvantaged and the deprived at every turn; how convenient it would be to wish them away with sleight of mind, like a cerebral rabbit in the magician's hat.

Northern Ireland is a case in point. Most English people, if they are really honest, have difficulty in recognising the people of Northern Ireland as fellow citizens. Few English people are remotely interested in trying to make sense of what is going on in Northern Ireland. They would rather see the Irish 'problem' go away.

We hear a lot about death in Northern Ireland, but we hardly stop to hear who is killing whom. We find it difficult to understand the passion that can cause such mayhem, ignoring perhaps the fact that some of the killing is done on our behalf by British soldiers. We refuse to comprehend the deep sense of injustice that has led to this desolate situation. If we hear of a father shot in front of his children, we find it appalling for a few seconds and then forget it. The children involved of course cannot forget, and probably never forgive, and that too is part of the 'problem'. The patterns of the future are woven from the suffering of today.

Sometimes, grandiose claims are made for the power of photography as a means to human understanding and social change. I doubt these myself. If the eye, and therefore the soul, is not seduced into compassion by human tragedy in the real world, I cannot quite believe a published photograph will work this miracle. I claim a more modest role for photography, that of opening the eyes in the first place, and therefore challenging indifference. Powerful images can blow away the mental and emotional cobwebs which surround us much of the time.

But documentary photography out of context can be dangerous. It can seduce us into false emotional and intellectual reactions to complex situations. A photograph randomly taken can sometimes powerfully convey the essence of a situation, but you cannot expect to capture the life of a community in a few hours. The photographs in this book are the result of many visits and much research and discussion. The pictures are diverse, witty, affectionate, disturbing, and often critical.

They reflect an everyday reality for a large part of the population of Northern Ireland which people in Britain would not or could not tolerate for a day, let alone two decades. At a human and social level, the photographs show that the Catholic community has a spirit and a resilience which is likely to survive almost every hardship. To recognise this passion is to acknowledge the humanity of the people involved and thus to abandon the peculiar British capacity to 'reify' large numbers of people who inconveniently challenge long held and cosy preconceptions. Things will not change in the world until we are honest enough to recognise our prejudices and allow them to be undermined by the unavoidable evidence of our eyes. This book is documentary photography at its best – imaginative, comprehensive, confident and concerned.

Colin Jacobson
Independent Magazine
May 1989

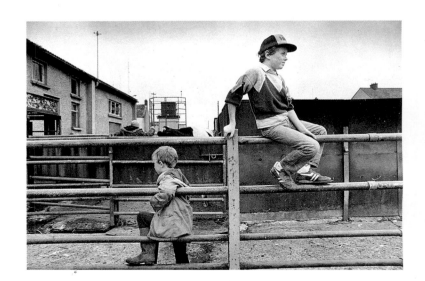

PREFACE

When I first went to Ireland, I met a remarkable woman, Moire Comerford. She was already in her late eighties and had been active during the Easter Rising in 1916. When I met her she was still writing, having worked as a journalist. Throughout her life she never gave up her belief in a united Ireland, nor her vision of a country where the wealth of the nation would be shared amongst all its people. She used to talk about Ireland's future being its youth, yet what she witnessed was mass emigration by generations who saw no future for themselves at home. While she lived in Dublin, her thoughts were always for the North, across the border, where she felt the people had taken on the responsibility of the nation as a whole. She used to talk especially of the children robbed of their childhood, of their right to daydream, and of parents who thought it would all be over before their children grew up and then found themselves faced with the fact that their grandchildren would be born into a similar situation of conflict.

It was 1982 when I moved to Derry. My enthusiasm for going to work there had been fuelled by events that were taking place: the hunger-strike of 1981 when ten men died in prison in their fight to be recognised as political prisoners – a recognition that had existed five years earlier. The pictures I saw on television were images of rioting, mayhem, young people taking to the streets, small working-class communities who had been struggling against injustice for over ten years suddenly deluged by the foreign press. We heard the media's versions and explanations, but rarely those of the people involved. I was invited to go myself, not to create yet another version, but to share my photographic skills with a group of young people who had decided they wanted to make their own photographs, to document their own reality. I planned on a year, I stayed four.

During that time, while working with Derry Camerawork, I experienced at first hand the reality of living under British occupation. While I remained an outsider, I was also welcomed into the community living in the Nationalist ghetto of the Bogside, another tenant of the Rossville flats. The level of harassment I experienced was nothing special; on the contrary, I am sure I was treated with more respect than my neighbours during those dawn raids when our homes would be taken apart and our privacy invaded. For me, it was something new and terrifying; for the people who had grown up in Derry, it was something they had learnt to live with – although I believe the oppression of occupation is something no one ever gets used to.

I watched the group of young people I worked with mature and change and have their lives involuntarily changed for them. Every aspect of life was lived as intensely as possible – from birth to death – with the deep understanding of its frailty. It felt as though they were permanently in a hurry. In November 1984, the husband of one of the young women I worked with was shot dead by the British Army. He was a member of the IRA, none of us knew. He could have been arrested, there was no need to shoot, no need to shoot him thirty-eight times. Another statistic of 'shoot-to-kill', another widow, another funeral, another film crew arrived for a brief stay, more footage, more photos. I did not attend the funeral. I remember I went for a walk with his son, then just a small baby whom I carried in my arms. I distinctly remember thinking at the time that this moment would bind us in some way, however loose our knowledge of each other would become in the future.

That Christmas I decided to go home. The project I had participated in setting up no longer needed support from me. My reason for going in the first place had been to share specific photographic skills. We had achieved that three years earlier. I had stayed on because the process was not a one-way thing; I was learning all the time. For me, living there was an education and a valuable experience. I had also learnt that my relationship would always inevitably be that of an outsider, and now I wanted to feel at home. So I chose to recognise the differences and return to London.

Running a picture agency in London gave me the opportunity to encourage photographers to go to Ireland and work on long-term essays rather than just respond to the news events. I was fortunate to be working with photographers whose understanding of photojournalism makes this way of working a priority rather than the sensationalist approach. In 1986 Mike Abrahams and Laurie Sparham, both Network photographers, chose to work with me on this project. We decided the book would be an essay on the Nationalist community – on the people I had lived and worked with during my years in Ireland. A book combining my research and experience with their photographs.

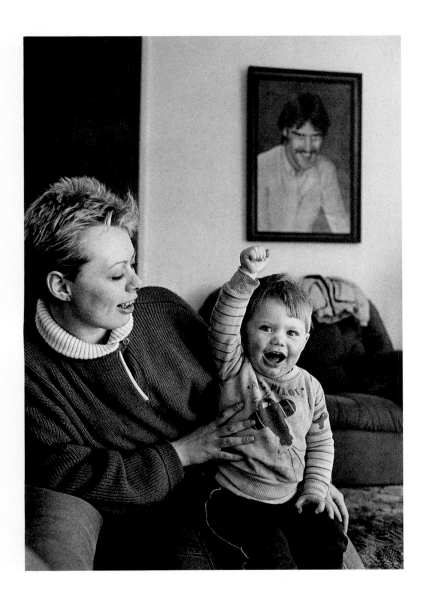

The book is a portrait of the Nationalist communities from three main areas: Belfast, Crossmaglen and Derry. The quotations, the voices, are from interviews with people who live there; their words with our pictures. They are people that I knew when I had lived there and others I had met on return trips. Young people on the street and in youth clubs, women in their homes and at meetings and rallies, correspondence from a young Republican POW in the 'H' blocks of Long Kesh. Different voices, visions and themes, together with the photographs, producing a view, of course an outsider's view, but one that is not seen on the news or described in the mainstream papers. Most of the photographs in the book are from moments between the news events. They are of everyday life, after the crews have packed up their equipment and gone home and the papers have been put to bed.

Still War is an attempt to describe a community, a group of people who are intent on determining their own future, a people who describe themselves as Irish and see Britain as another country whose soldiers are a foreign army of occupation. They see themselves at war in a country whose borders are unresolved and whose civil rights have been removed.

Some of the scenes in the photographs would not look out of place in Manchester, Liverpool or Bradford. The difference being that these streets are occupied with soldiers and the paraphernalia of war. The images are familiar and yet strange. The people similar but of a different culture. This is Ireland not Britain.

Trisha Ziff
Editor

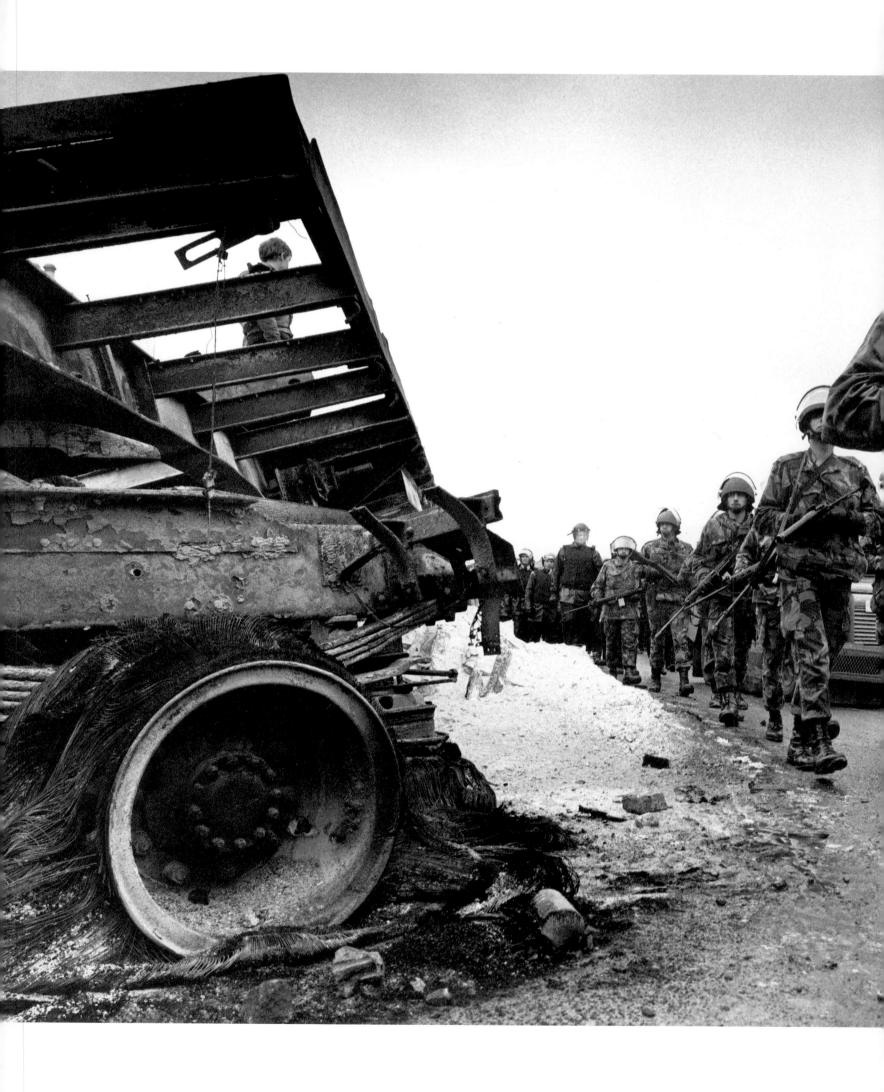

British soldiers patrol a Republican funeral, Ardoyne, North Belfast, 1987

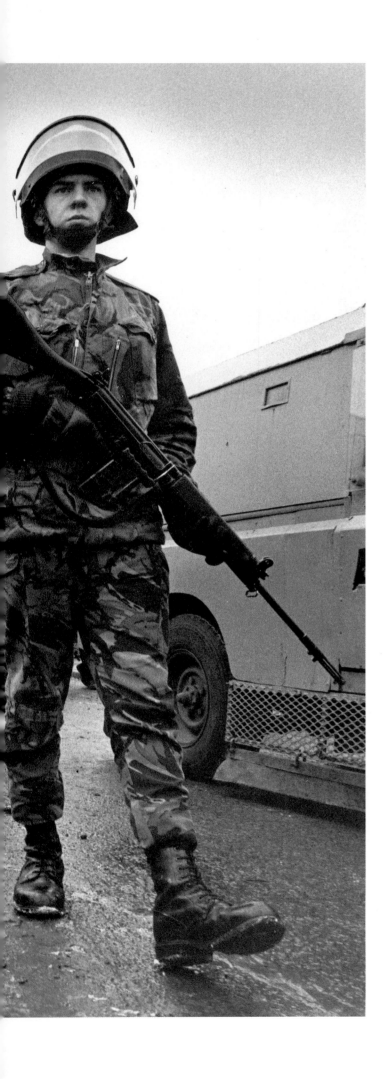

War is never glorious, never desirable; it is sometimes necessary and often inevitable. It conjures up images of trenches and cannon fire, legions of men and weapons.

These images help to distance us from reality. War belongs to other times and other places. 'The British are not at war.' Soldiers, weaponry, emergency powers, barbed wire, media co-operation in restricting information are but peacetime measures to deal with 'terrorism'. 'Terrorists' are not real people. This is not real war. Once the initial reality is lost, the first unconscious step is taken to distance the mind from the unpalatable, unacceptable truth: the image becomes its own reality and every distortion of fact thereafter develops a life of its own, based on the false assumption that the initial premise is not true.

For twenty years the fabric of that distortion in Northern Ireland has been deliberately and intricately woven with such intensity that only those determined to come and, at all costs, seek the truth for themselves stand the slightest chance of finding it.

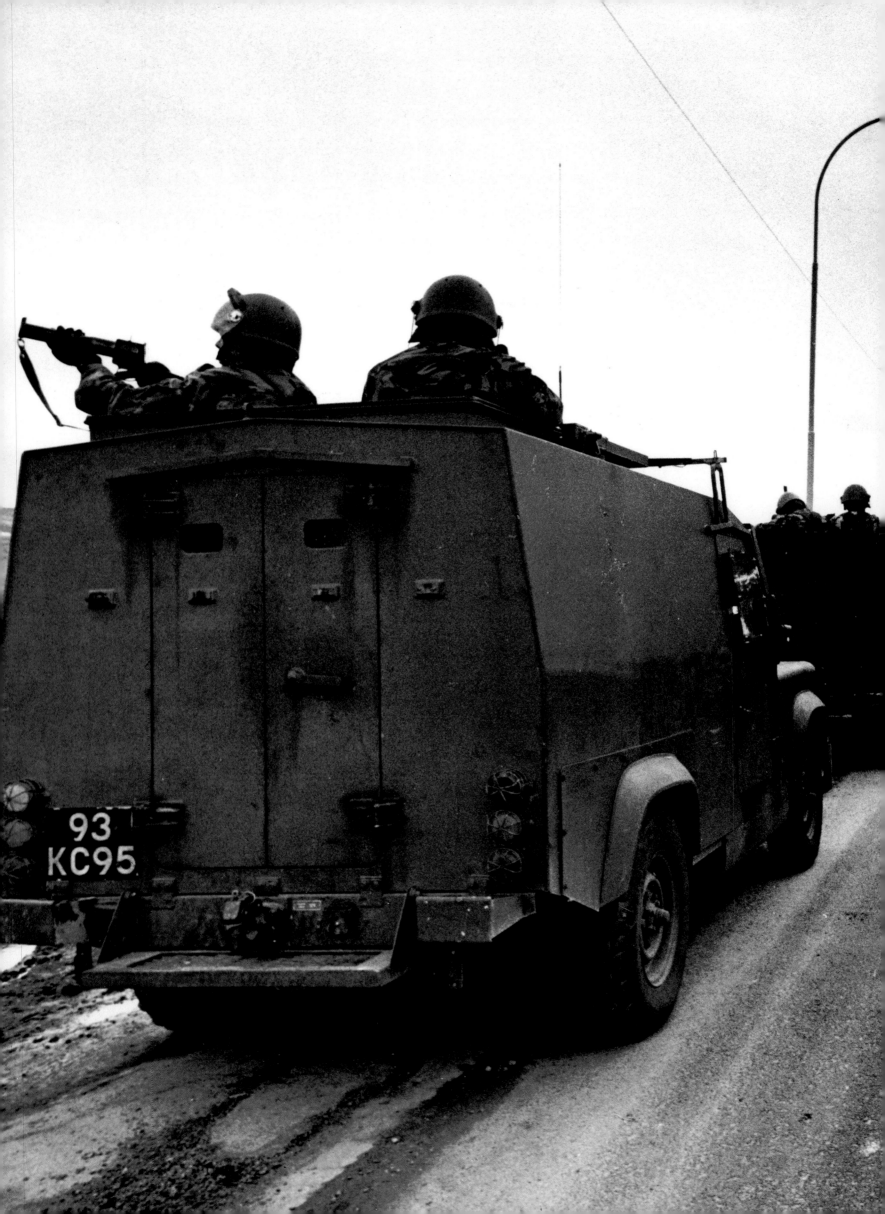

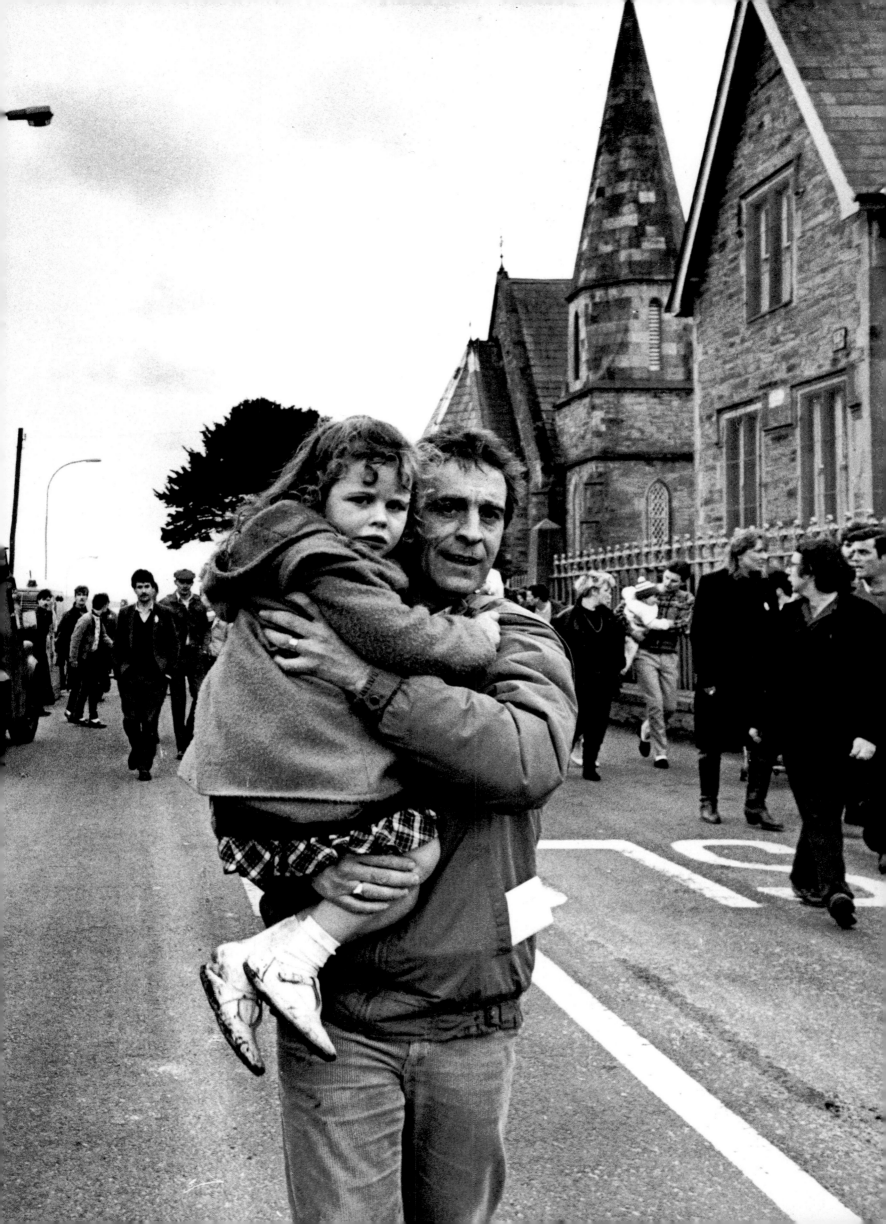

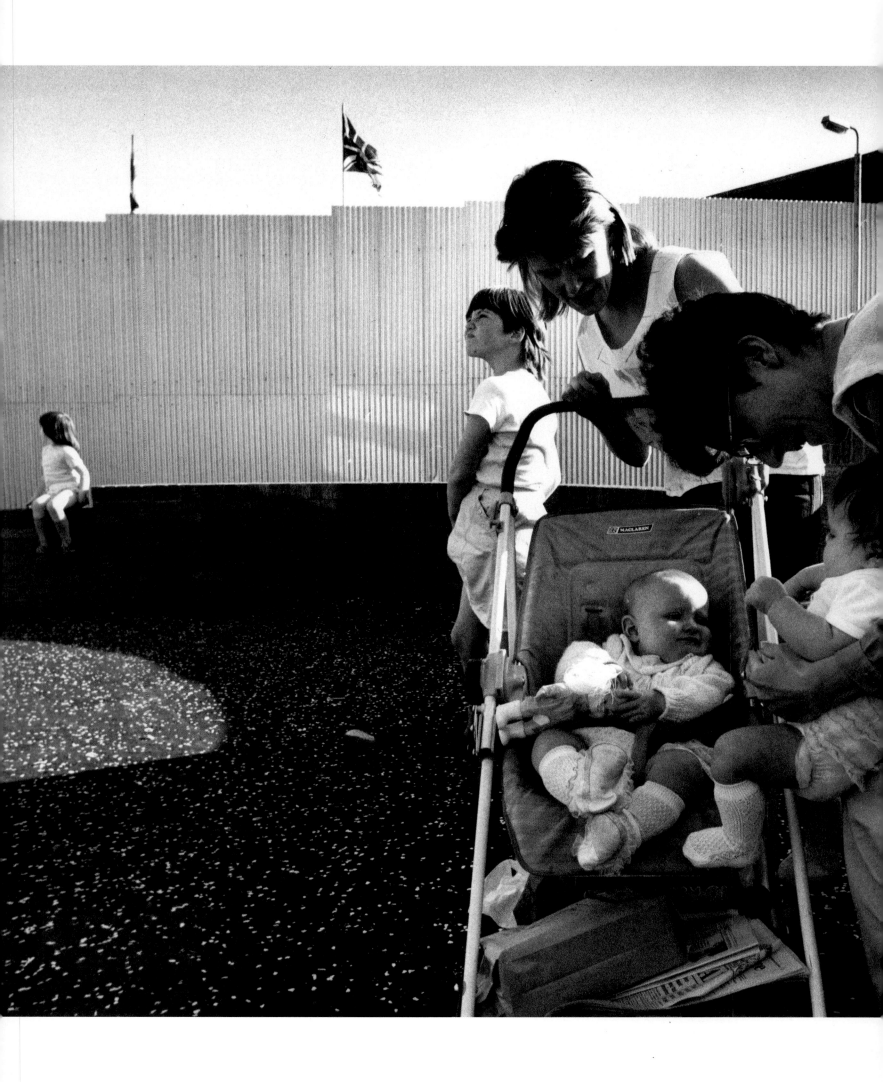

Corrugated iron wall dividing the Nationalists from the Loyalists, Manor Street, North Belfast

The unspoken images of reality and truth in these photographs portray human beings as exactly that, real and true. Here we see people caught by the camera, being themselves in circumstances not of their own making and over which they have very little control.

The myth of 'non-existent war' requires you to believe that the faces on these pages belong to some pathological conspiracy to destroy democracy, That they want only to deprive their brother and sister citizens of life and liberty. If there is no war, no conflict, no struggle, save 'the eradication of terrorism', no legitimate demand for justice, then these must be the faces, however young or old, of 'terrorists', for here in still life are glimpses of the Republicans, the minority of Northern Ireland.

Man, woman and child, these people have suffered the ignominy of discrimination, poverty, inequality. They have felt the force of British law, in all its 'due process' — internment without trial, no-jury special courts, interrogation centres, savage prison sentences, and the paid testimony of supergrasses. They have felt the peacetime 'protection' of plastic bullets, tear-gas, curfew, emergency legislation, 'shoot-to-kill' policies, early-morning raids.

Over twenty years they have buried their dead, comforted their widows and orphans, visited their prisoners, fought their corner as best they could, and got on with their lives. For the lives of these people are not separate from 'the troubles': the paraphernalia of war is part of the fabric of their environment, the pain of war is an integral part of their lives.

Irish Republicans, like British soldiers and policemen and judges and those referred to as 'innocent' victims, have families, have homes, have friends who love them dearly. To believe, in accordance with the constitution of Ireland, in the rightful re-integration and independence of our nation should not mean that we forfeit the right to be treated and be seen as ordinary decent human beings. For twenty years that has been the price we have been forced to pay.

Nearly two centuries ago, Robert Emmet struggled that we, the Irish people, might take our place 'among the nations of the earth'. From 1968 we have struggled for the right to be recognised amongst the earth's oppressed.

Still War is a contribution to establishing the stark reality of that truth; as such, it can be charged and found guilty of 'disturbing the peace'.

Bernadette McAliskey

September 1988

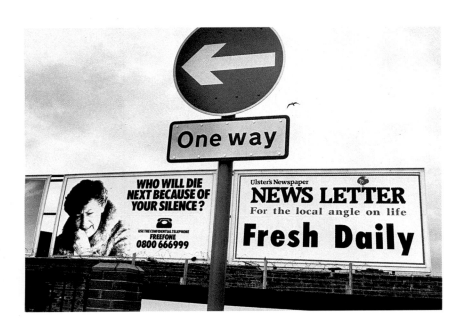

Different messages, Lower Falls, Belfast

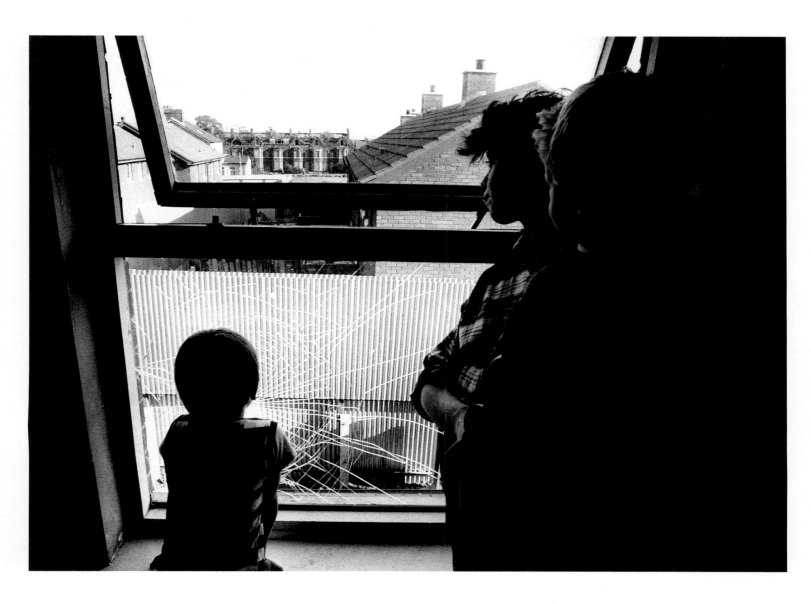

Corrugated iron wall dividing the Nationalists from the Loyalists, Manor Street, North Belfast

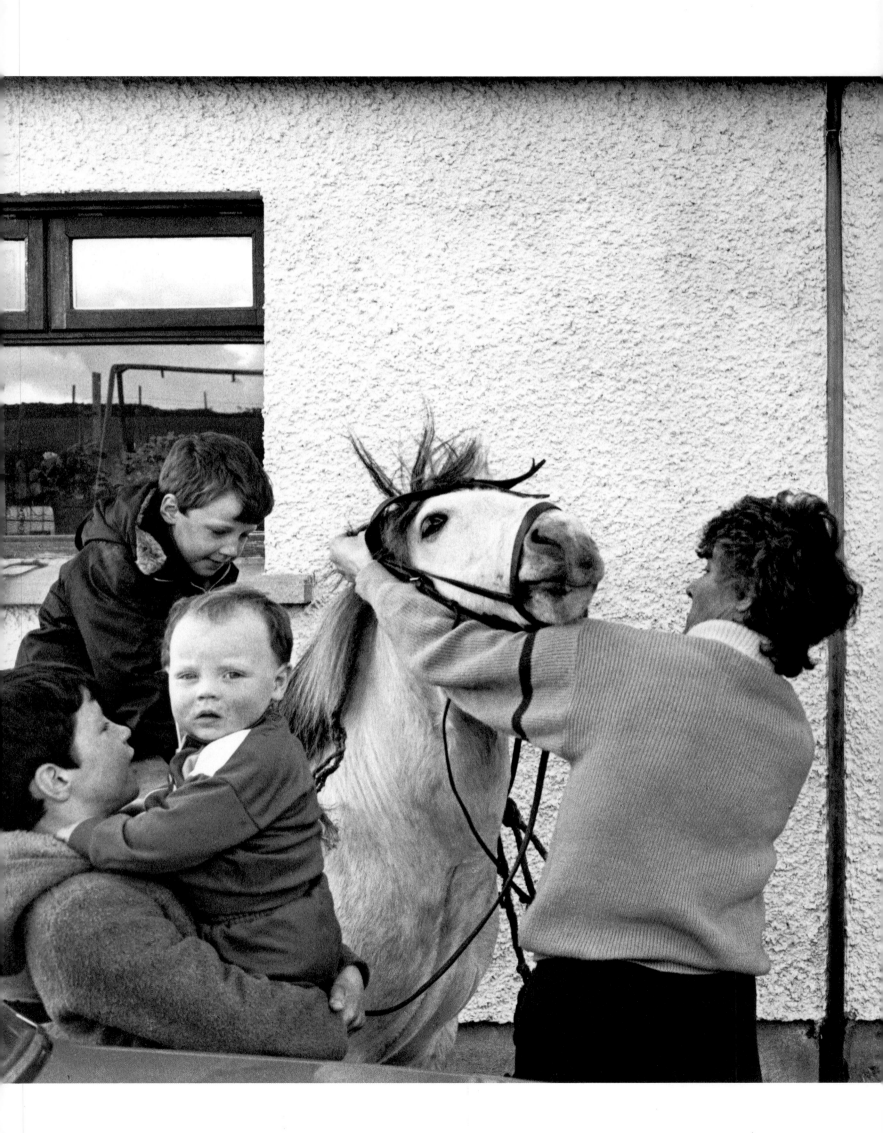

Home in Carrickmore, County Tyrone

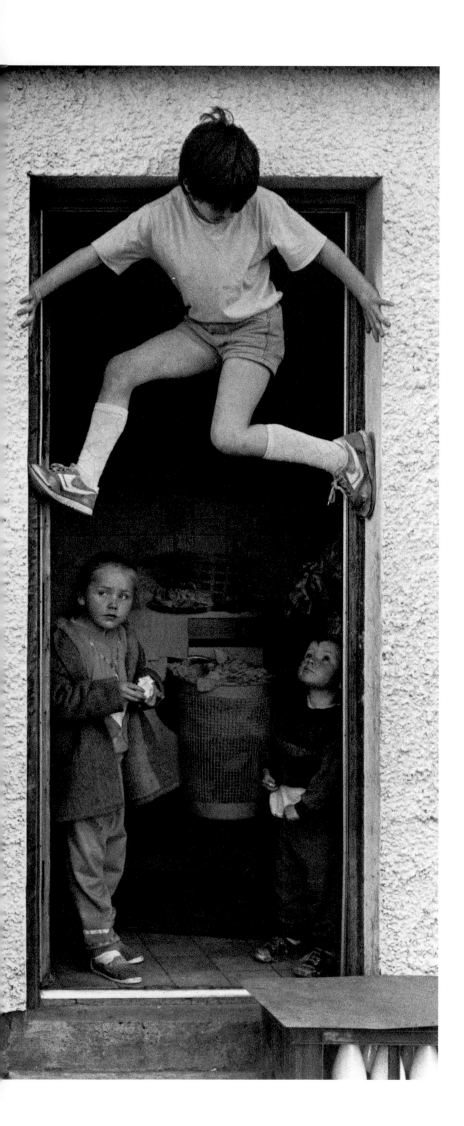

INTERIORS

What is important is what is not shown. The things one cannot see are those that impinge most on your life . . . that you are being watched, and that surveillance happens continuously. You cannot photograph these things. They are not public. They are not seen. How can one photograph a psychological state that you experience daily. Surveillance is a condition – it happens all the time. It is like the weather in winter, constantly grey. There is no break. It is only afterwards that you realise the extent of the oppressive situation that you were in.

Willie Doherty, Artist, from the film *Picturing Derry*

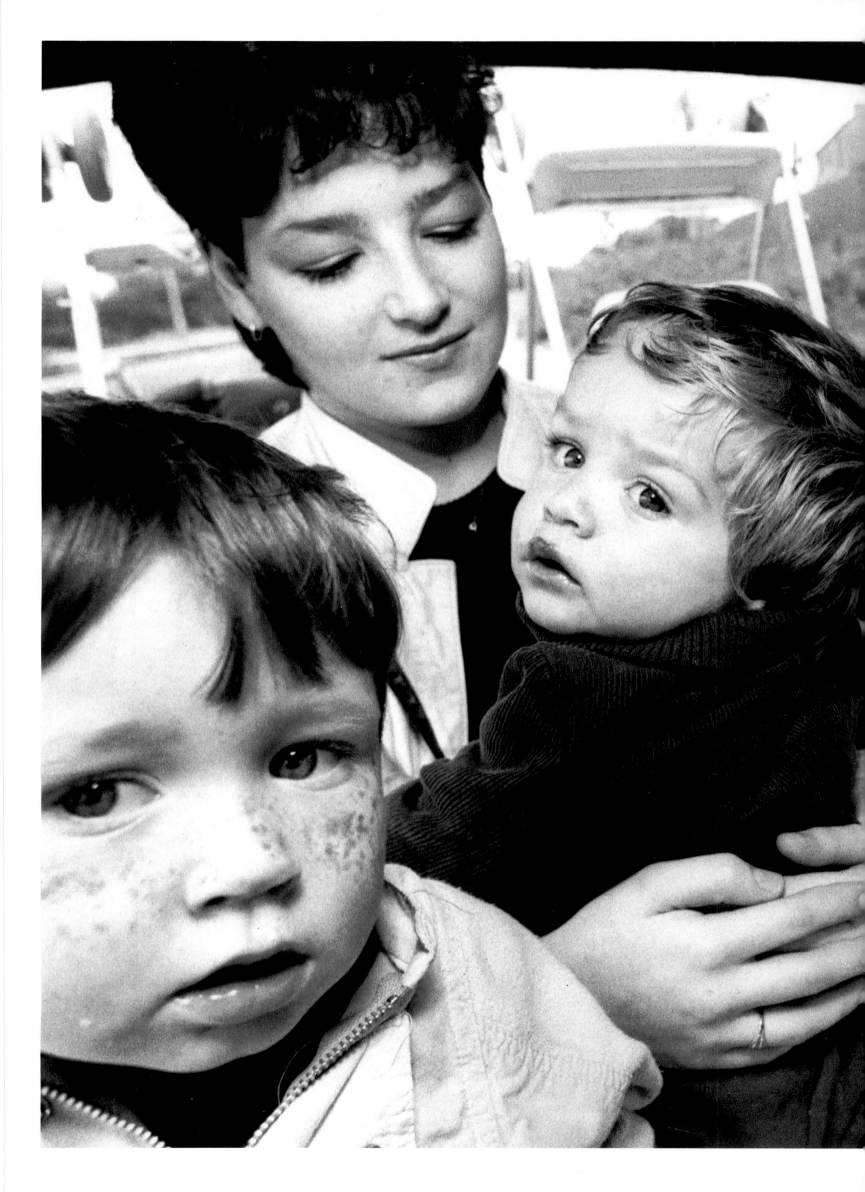

Community, black taxi, Falls Road, Belfast

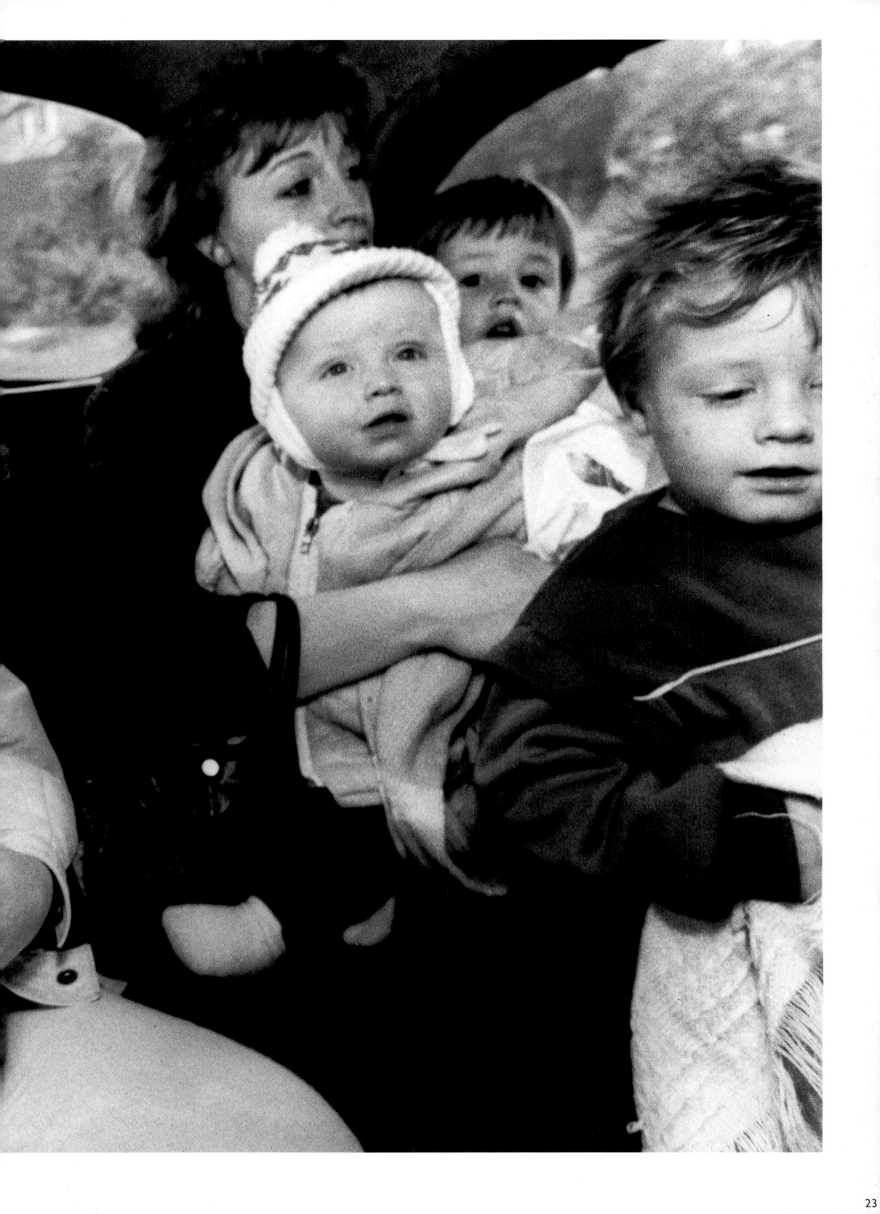

Reading the news . . . front room, Cullyhanna, South Armagh

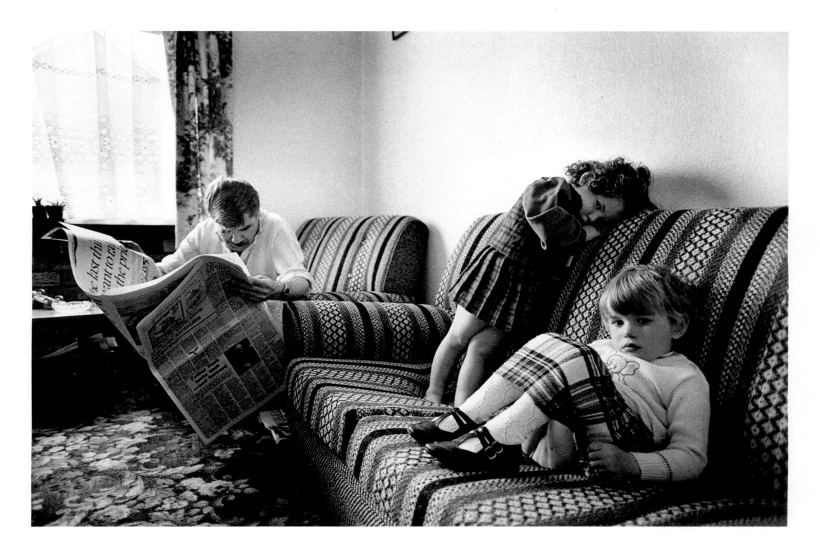

[1968]: The Bogside was deluged with journalists. Some spent their time trying to identify a local Danny the Red. (The May events in France were fresh in the memory.) Others wandered into the area and asked to be introduced to someone who had been discriminated against. A lady journalist from the *Daily Mail* came to my front door asking for the name and address of an articulate, Catholic, unemployed slum-dweller she could talk to. Derry was big news.

Eamonn McCann, *War and an Irish Town*

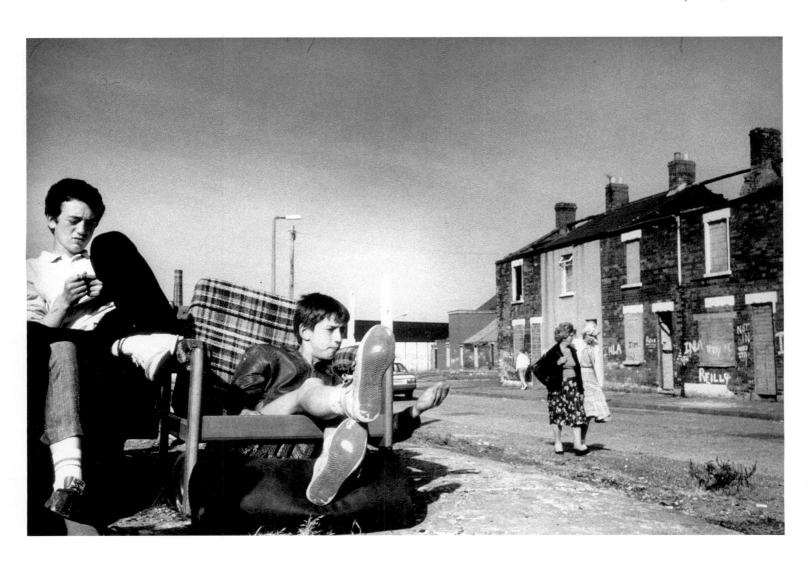

Interior becomes exterior, everything is on show. The front room might as well be on the street. Everything is on record. The style of wallpaper, the colour of the three-piece suite, what you had for breakfast. The job is to know. The Brits believe they see everything.

Trisha Ziff, *Pictures at War*

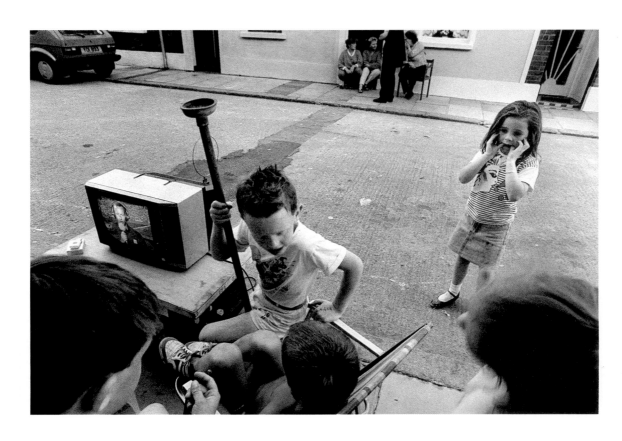

Ireland 1 . . . England 0 . . . European Championship '88, Cavendish Street, West Belfast

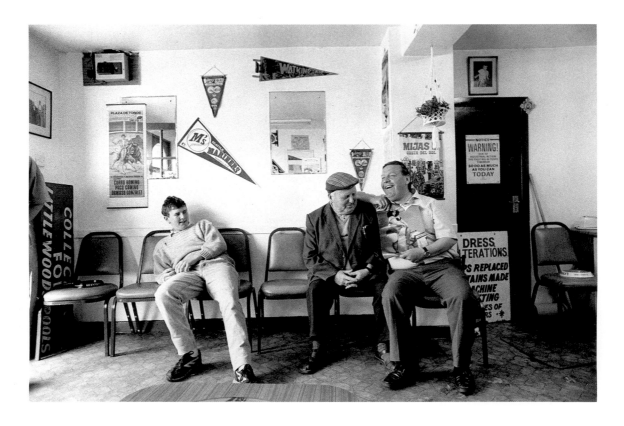

Barbers shop, Falls Road, Belfast

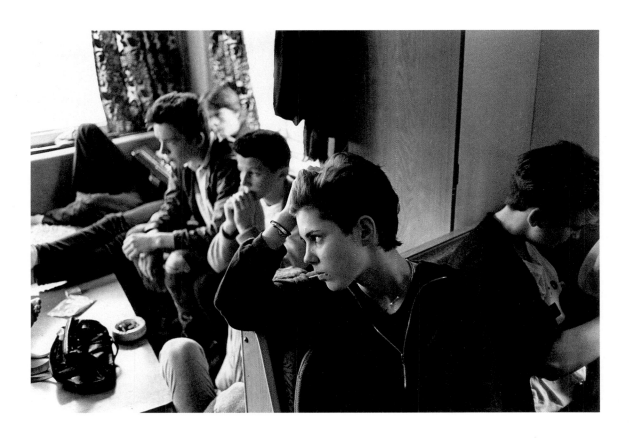

'Top of the Pops', holiday caravan, Waterfoot, County Antrim (popular holiday resort for the Nationalist community of Belfast)

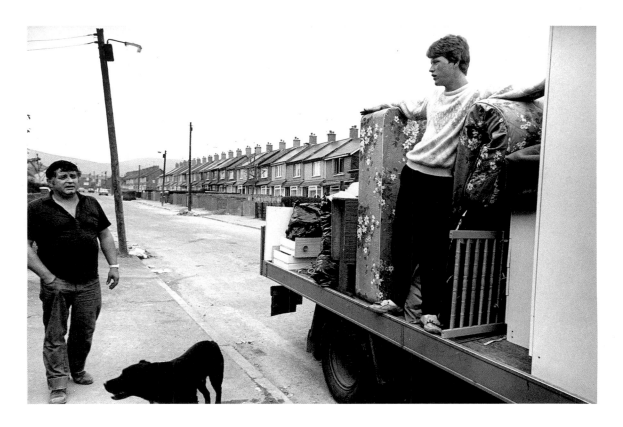

Nationalist family forced out of their home after Loyalist death threats, Ardoyne, North Belfast

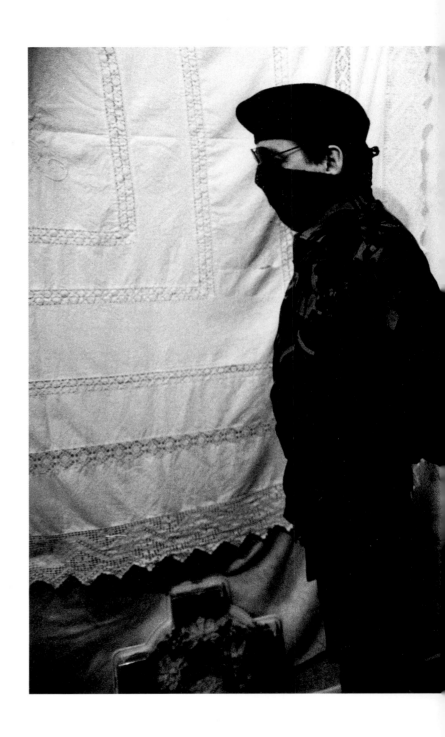

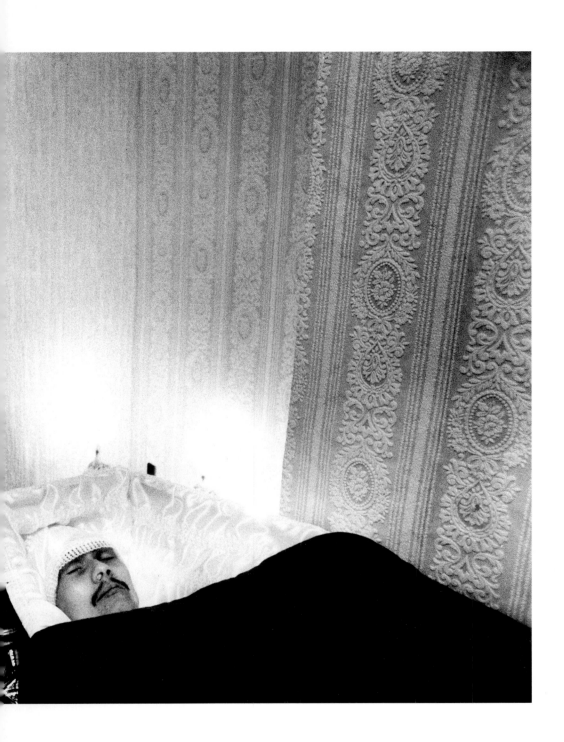

IRA guard of honour at the wake of Dann McCann, IRA volunteer, at his home in Cavendish Street, West Belfast
(Dan McCann was killed on the streets of Gibraltar by the SAS 6 March 1988)

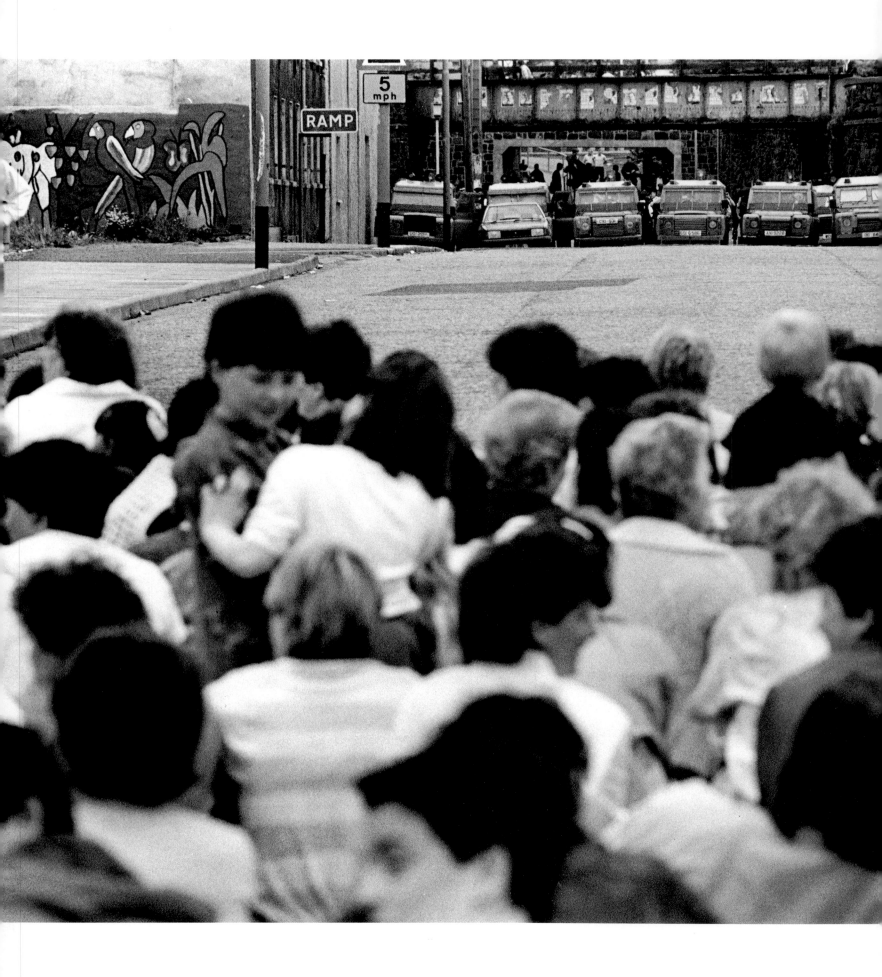

Ireland, as distinct from her people, is nothing to me; and the man who is bubbling over with love and enthusiasm for Ireland and can yet pass unmoved through our streets and witness all the wrongs and suffering, the shame and the degradation brought upon the people of Ireland – aye, brought by Irishmen upon Irish men and women – without burning to end it is, in my opinion, a fraud and a liar in his heart, no matter how he loves that combination of chemical elements he is pleased to call 'Ireland'.

James Connolly, *The Workers Republic,* 7 July 1900

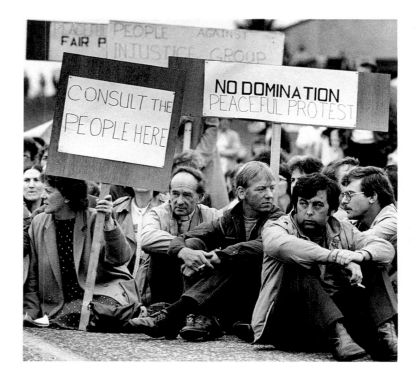

'The Tunnel', Portadown. Nationalist people protest against a Loyalist march (Part of the weeks of tension leading up to the 'Glorious twelfth')

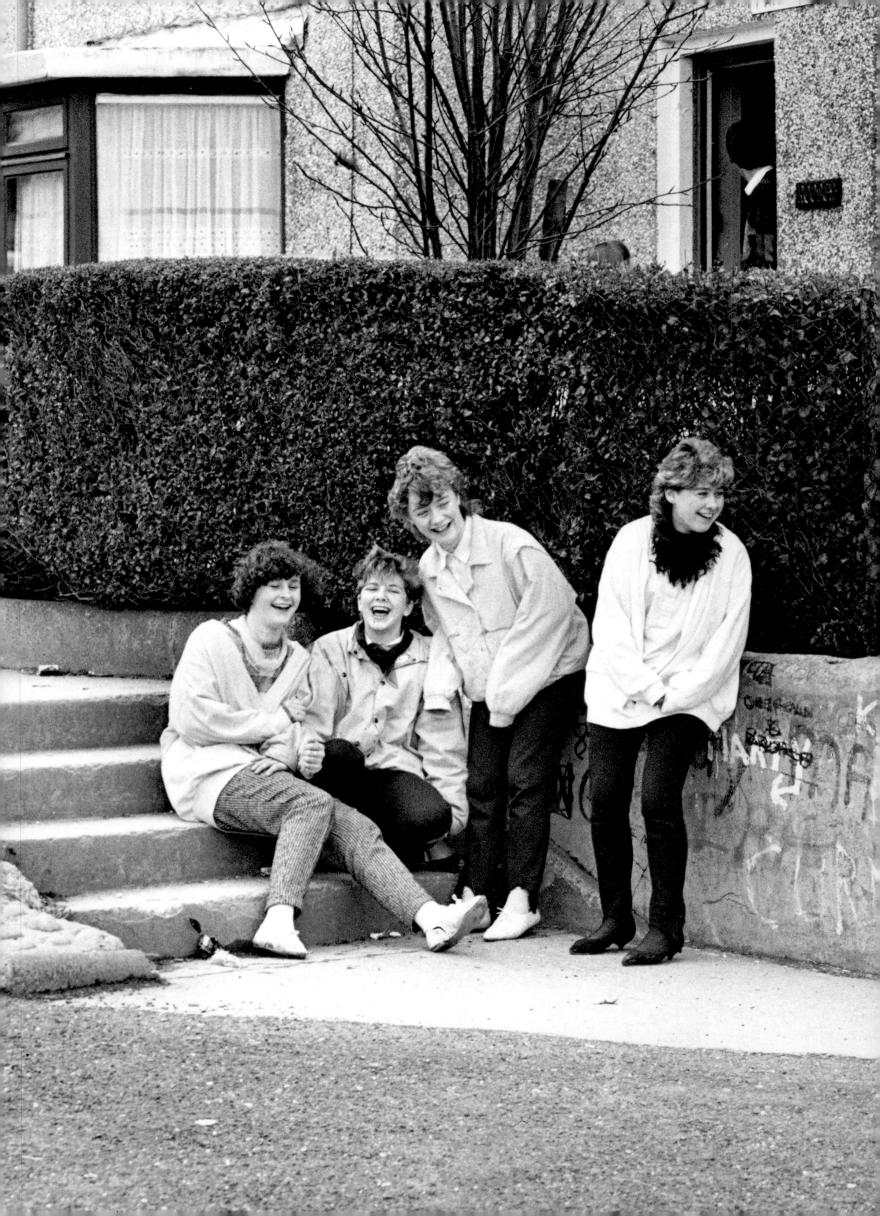

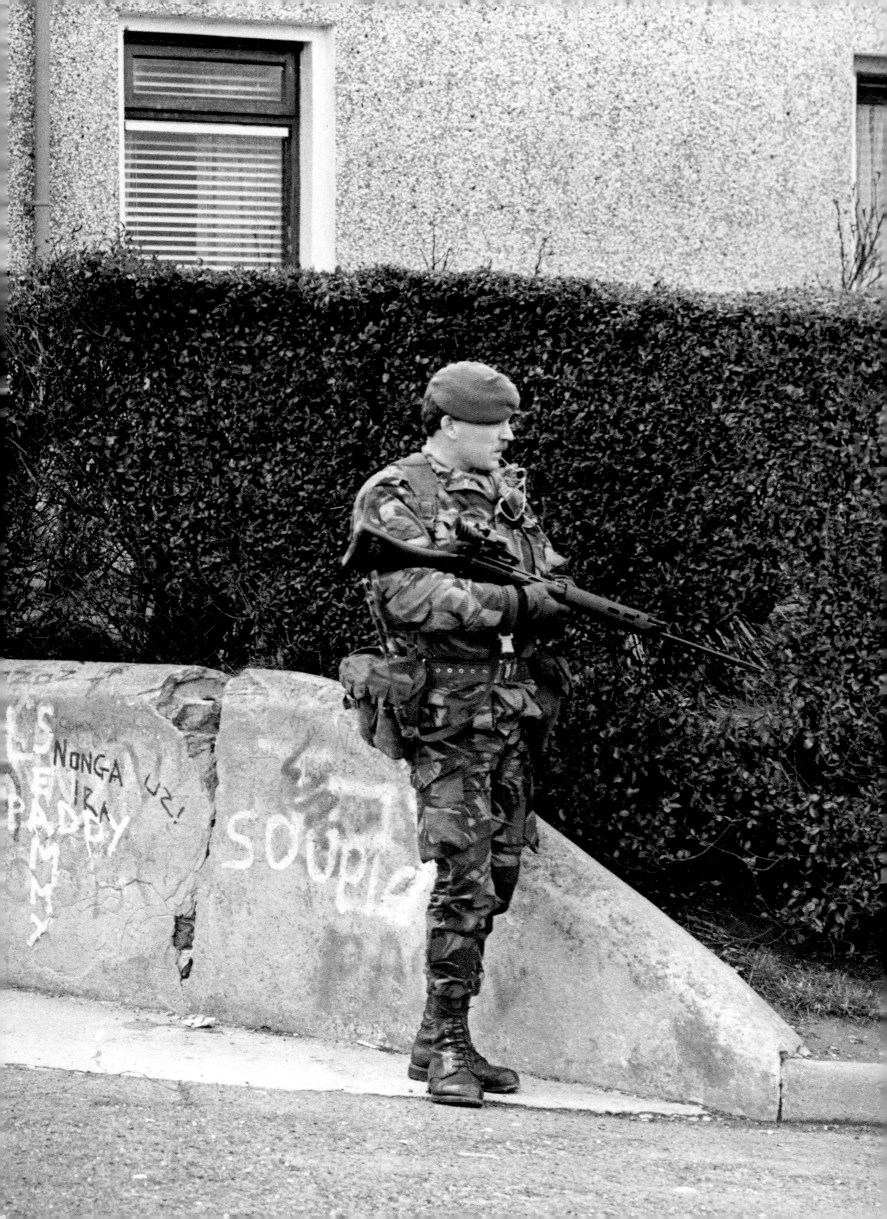

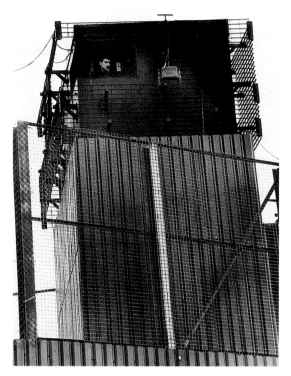

British Army watchtower, Crumlin Road,
Belfast

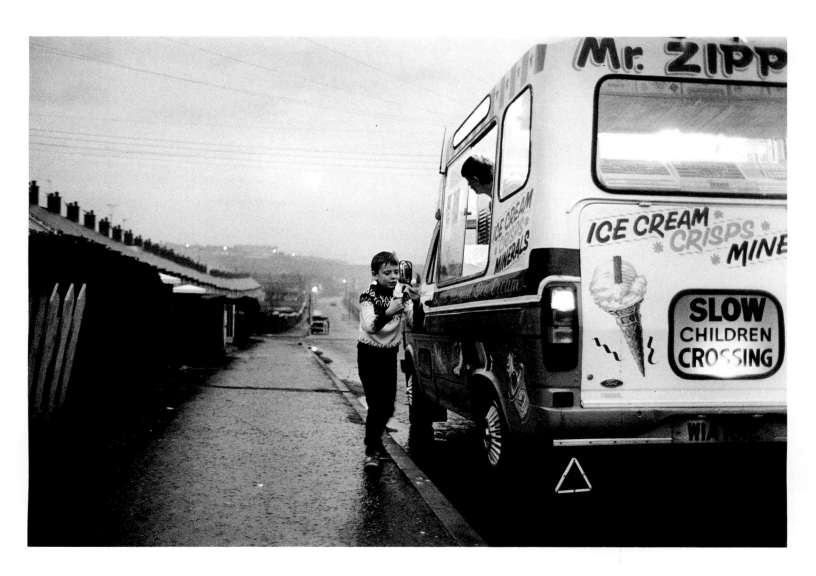

Mr Zippy, Ardyone, North Belfast

. . . normal life over here means something different to over there. The war shapes some people's lives, while it disrupts others. In our area it's impossible to forget the war, in others you could almost never see a trace of it. The Brits have tried to *normalise* daily life, to give an impression nothing is wrong. In the areas where tactically they desire to do this it has totally failed. These are the Nationalist areas – after all, getting your door kicked in, your home wrecked, being stopped and questioned on your way to the shops, to school, to the bru, whatever . . . curfew on the streets, seeing relatives dragged off to prison, people killed, armed foreign soldiers pointing their guns sneaking round street corners, always looking down, keeping watch . . . Not to mention barbed wire, armoured cars, saracens, pigs, cameras, videos, walkie-talkies, fortresses, road blocks, boulders, helicopters, graffiti, murals, mesh, corrugated walls. These are not the signs of normality.

Kieran Pritchard POW
Extract from a letter from the 'H' Blocks, Long Kesh Gaol

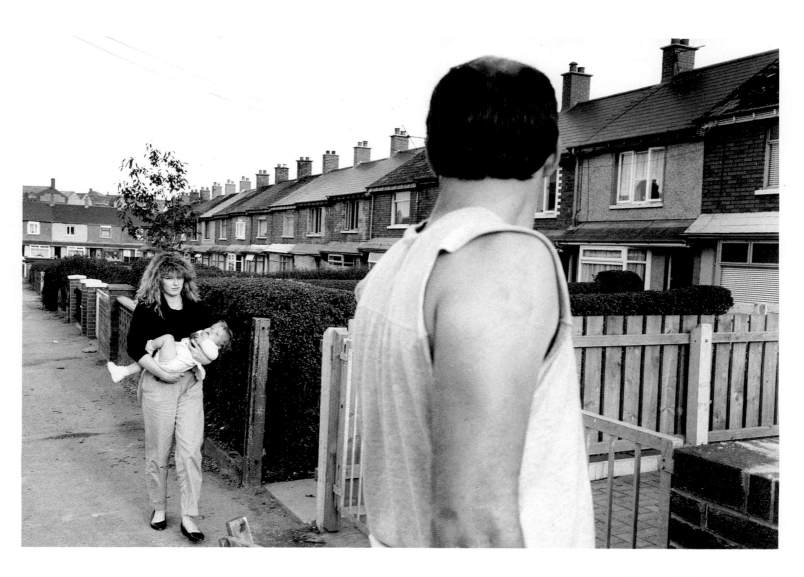

Teatime, Ardoyne, North Belfast

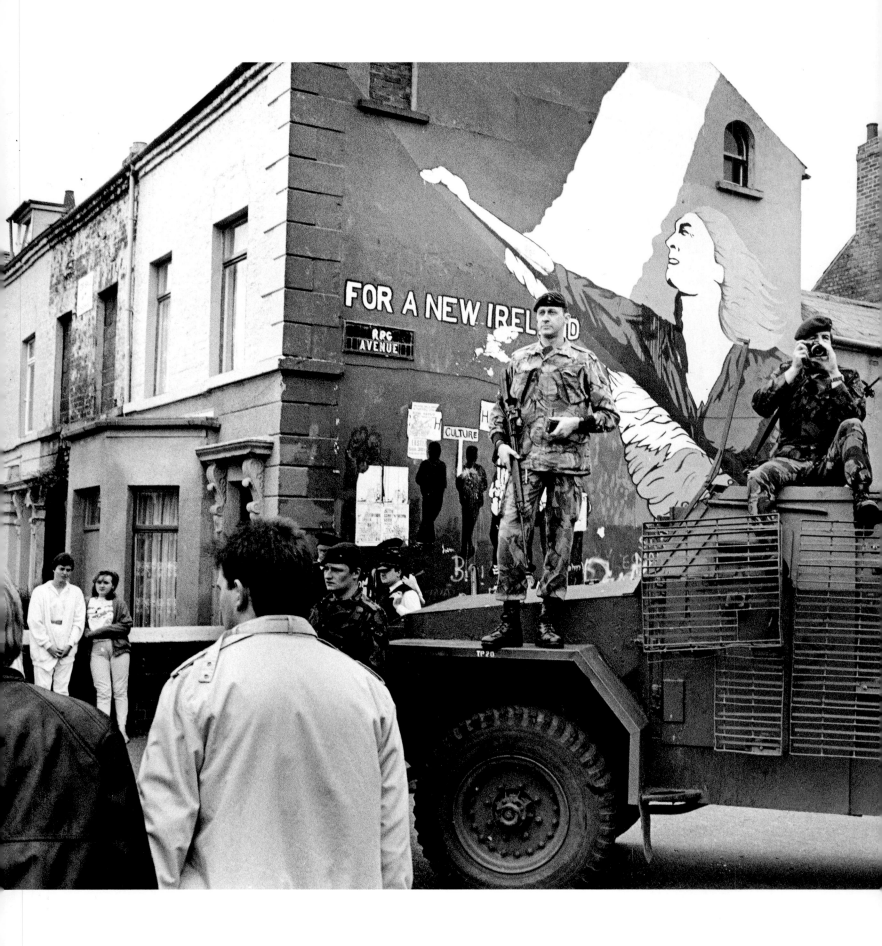

British Army photograph participants at Internment Commemoration March, Falls Road, Belfast, 1987

The photojournalist is there to take photographs for publications, newspapers. He is in the business of selling photographs. He just wants to make the most dramatic photograph he can. We are not in the business of dramatising things. What we want is a photograph which shows the individual person engaged in street disorder situations or whatever. Our photographs are not for sale.

RUC photographer, from the film *Picturing Derry*

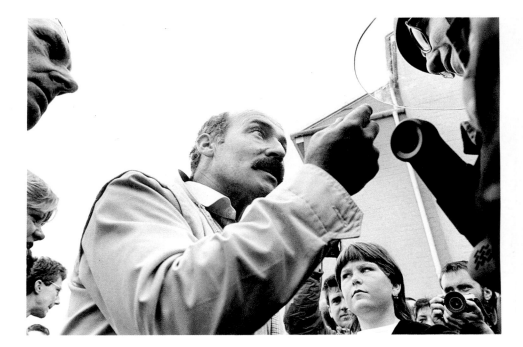

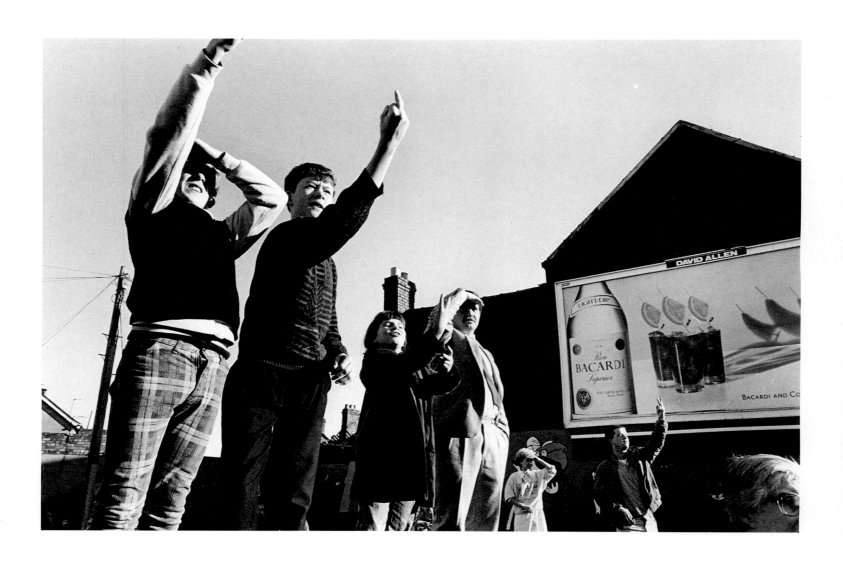

Incident on the Crumlin Road, Belfast

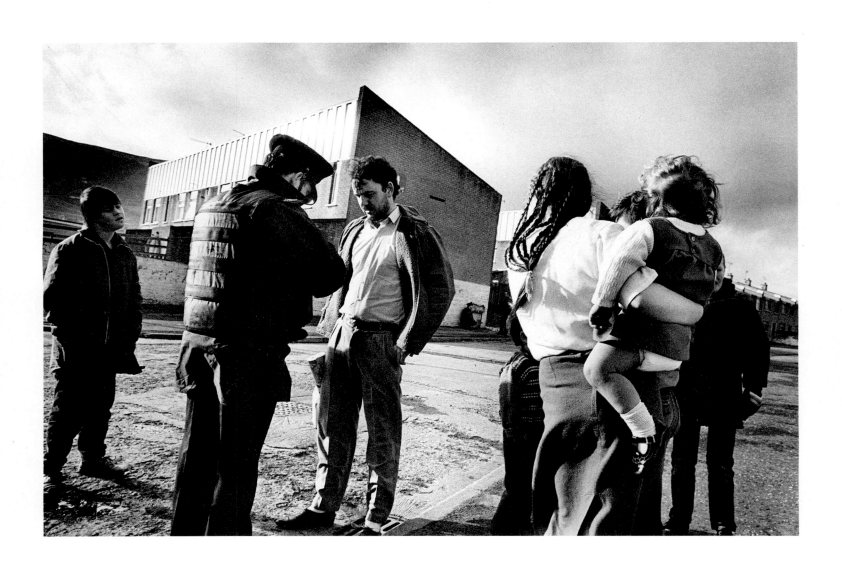

Routine RUC 'stop and search', Springhill Estate, Belfast

*'Give me your name', said
the RUC man.
'No' replied Jimmy,
I can't do that,'
'Why'?
'Well, if I give you my name,
then you'll have two and
I'll have none!'*

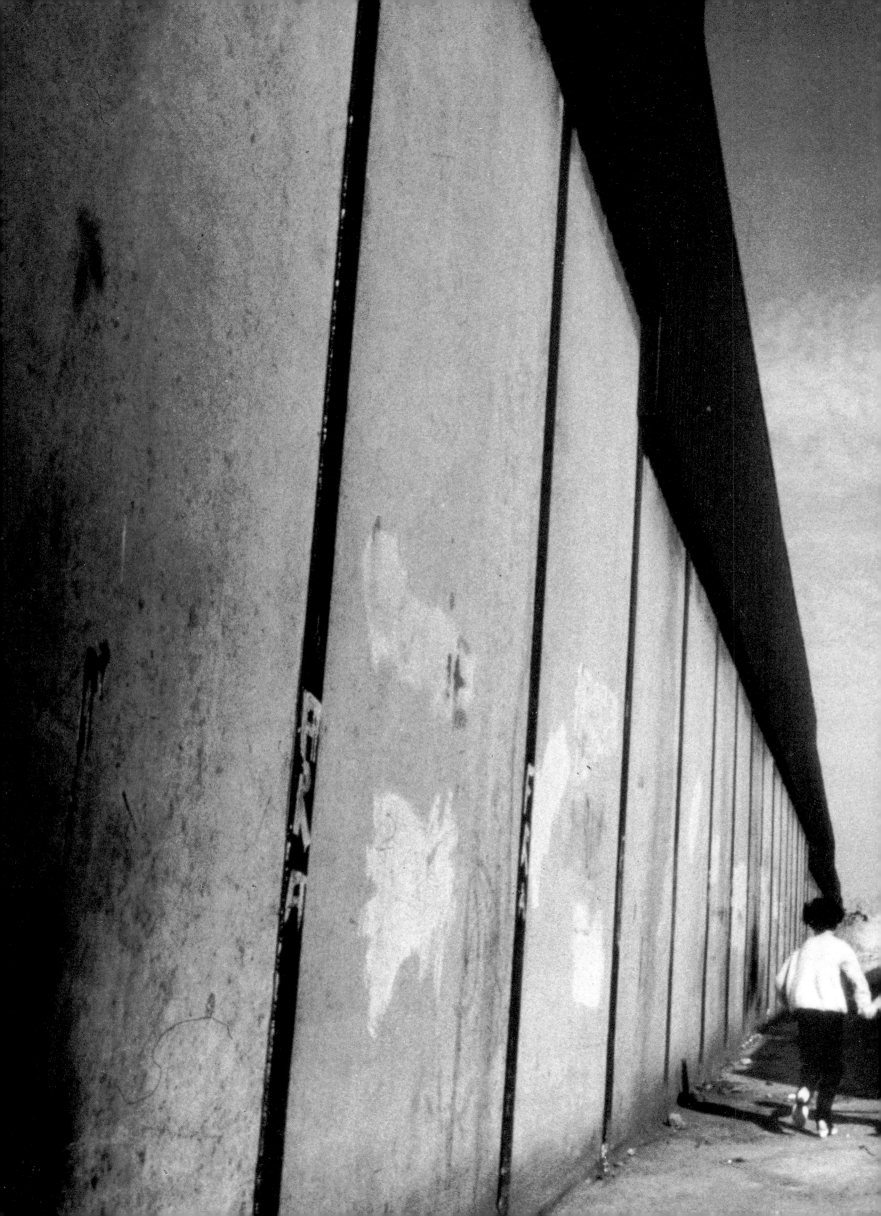

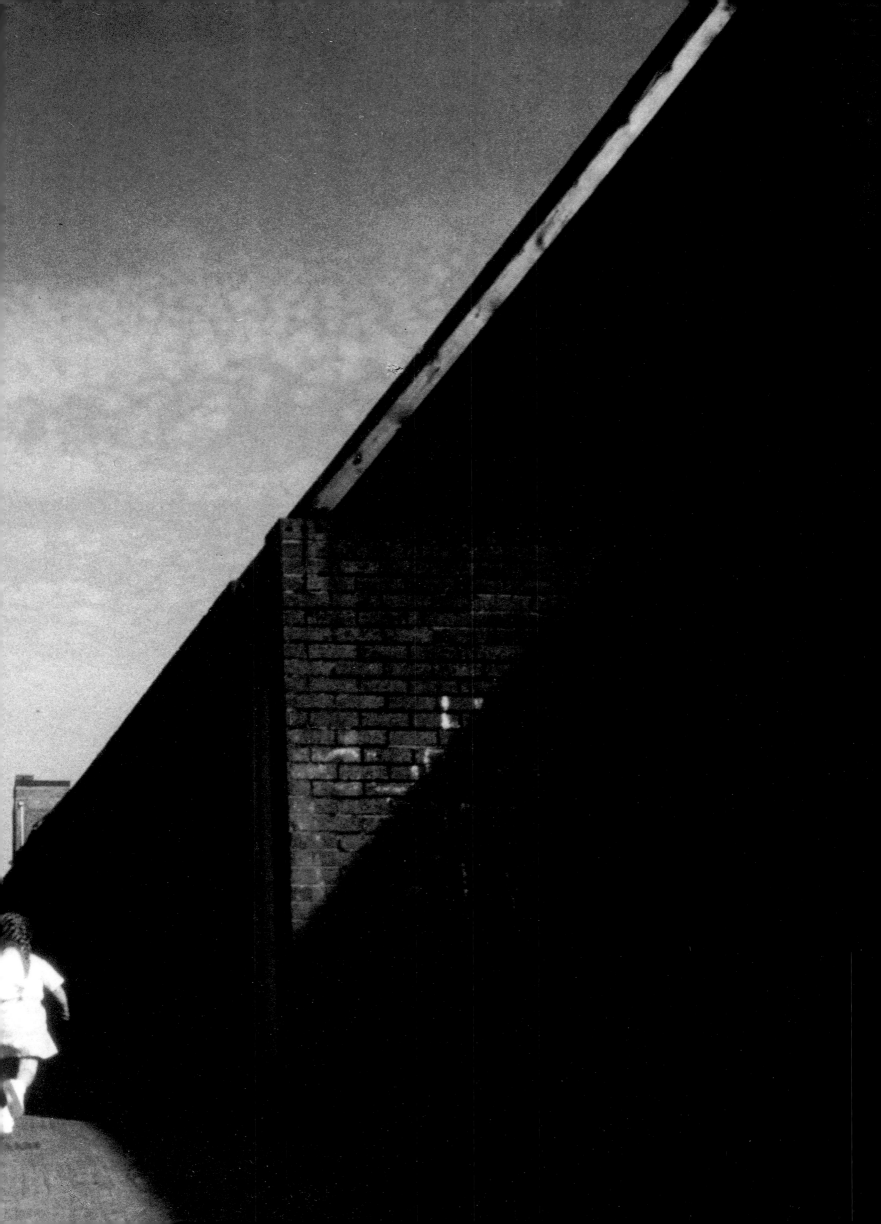

The letter 'H' cut out from the blanket worn by Republican prisoner Kevin McCracken during the blanket protest in the 'H' blocks of Long Kesh.
He was shot dead by British troops while on active service for the IRA in March 1988. Turf Lodge, West Belfast

PRISON

'Sad homes', Mrs McCracken kept repeating, 'sad homes. He was eleven when the soldiers arrived. He was twenty-one when he went on the blanket. The Anglo-Irish Agreement was signed on his release day, having spent eight years and five months in Long Kesh. On the day his comrades' remains were brought home from Gibraltar, Monday the fourteenth of March 1988, he was murdered. He was thirty-one.'

Mrs McCracken

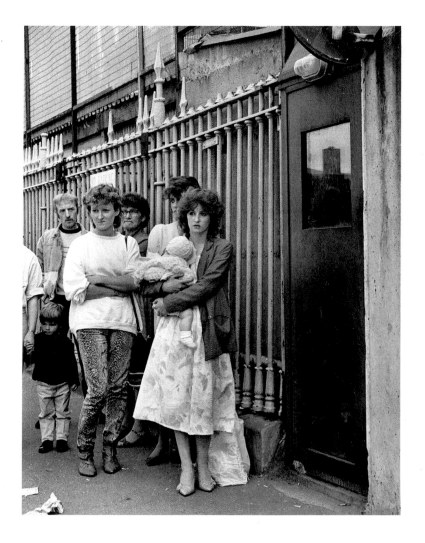

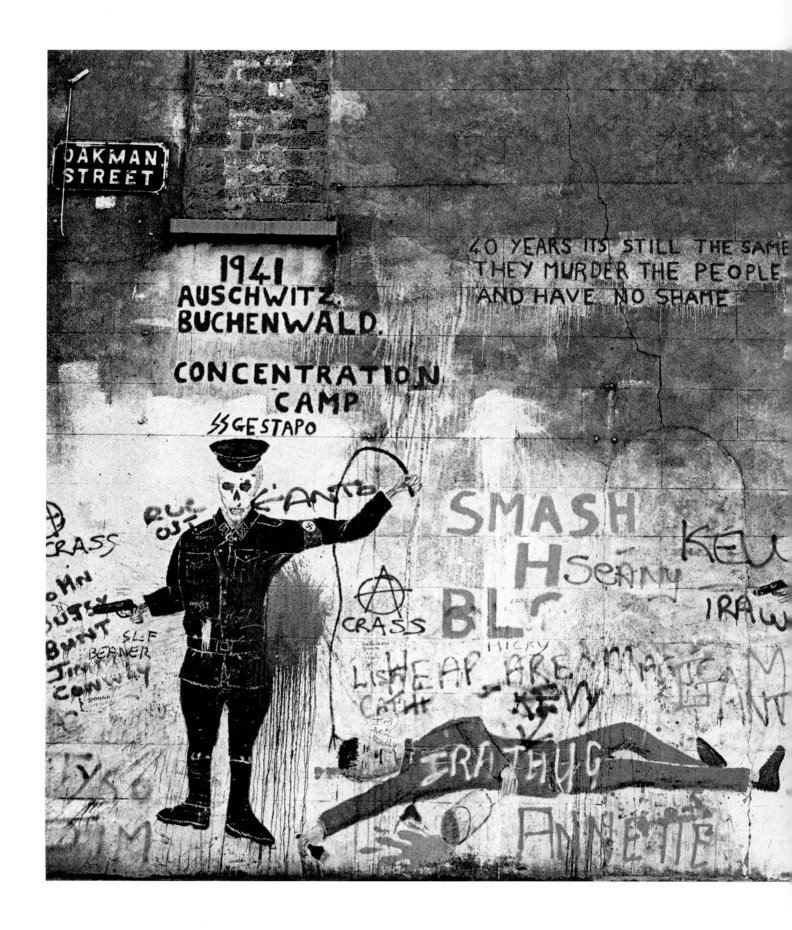

44 Wall, Oakman Street, West Belfast

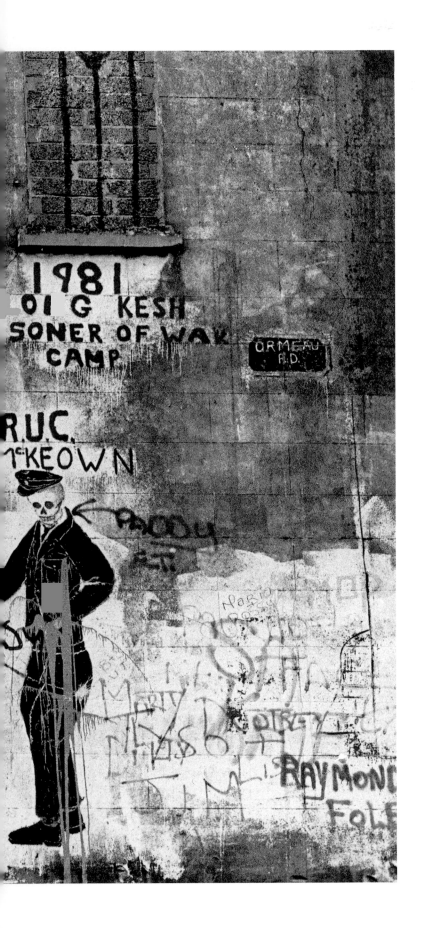

'Empty your chamber pots if you wish' they say, 'but only in the fashion that we can degrade you' – 'Wash yourself, but only in a fashion that we decide! – Go naked – or wear prison underwear.' We all know the attitude. It is the same attitude of the same oppressive authorities outside; 'Take a concrete tomb-like flat in Divis Flats or live on the streets', they say. 'Work for a little or don't work at all and starve', or, 'You may vote every four years. If you don't like it, too bad,' and that's that as 'they' say!

Bobby Sands, *Skylark Sing Your Lonely Song*

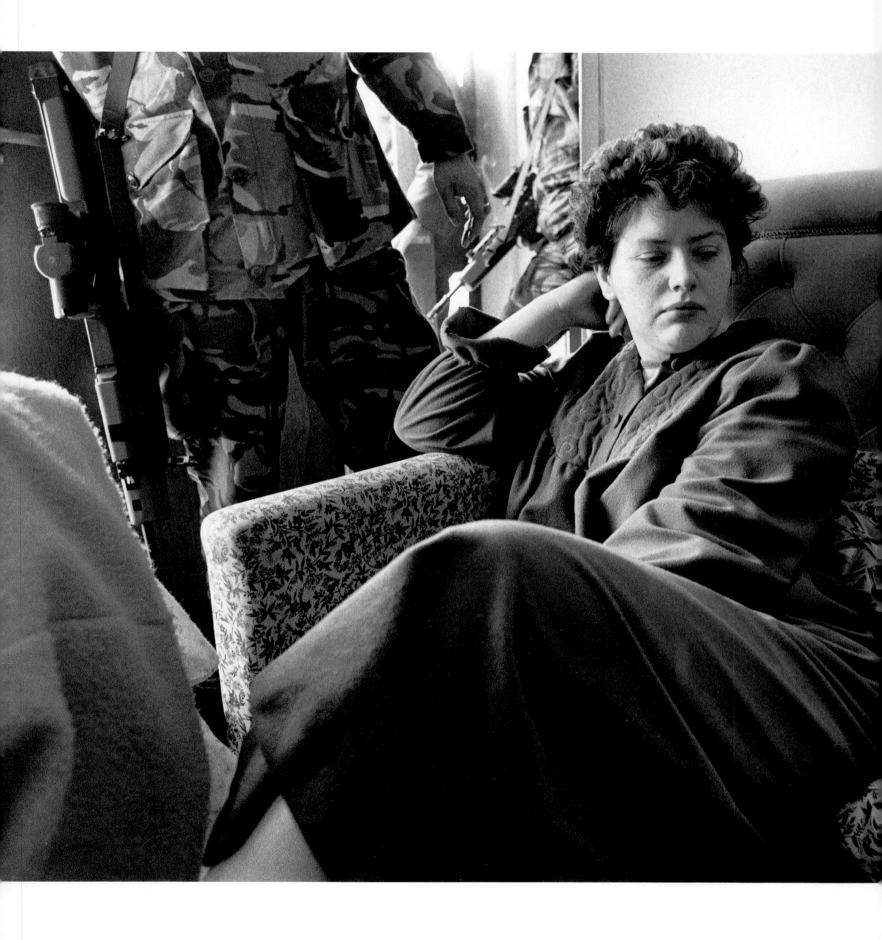

Dawn raid, British Army in Ardoyne, 1988

The soldiers move in groups and take position at the top of the stairwell. On each landing, crouching down behind pillars, they adopt heroic postures, running from one to another to pose again, as if under attack, playing at being soldiers in the bush. There is no undergrowth here. These are people's homes, probably little different from their own back in Bradford, Glasgow or Cardiff.

The thud comes, the voices now clearly distinguished. Throwing on clothes quickly. To be dressed is to be less vulnerable. Opening the door a stream of armed men rush in and down the stairs, the carpet hoovered only yesterday is now covered with muddy footprints. They look quickly through all the rooms, make a head-count and assemble in the small over-crowded sitting room filled by the three-piece suite and eight soldiers. The soldier in charge reads out his search warrant. One of them sits down in an armchair to re-tie his boot lace, making himself at home.

No shelf, no cupboard, no box of cornflakes goes unchecked. The most private of belongings becomes a source of entertainment, nothing is personal, the place is now a tip. So much for the housework.

On finishing, there is a small formality: the damage form must be signed. Here vandalism takes on a new meaning. The Housing Executive print forms for this occurrence. It is part of daily life, routine procedure . . .

Down in the square, the Landrovers gather. A young man is being dragged across the waste ground, his shirt hanging out at the back, his laces still untied, hands shoved behind his back. He struggles uselessly against his escorts. His walk is awkward. They throw him into the saracen – you can hear the noise of his stiff bones against cold steel – the back doors slam shut, he is gone from view. The convoy leaves, tyres shriek, doors bang as if in panic, then silence. The destination unknown.

Soon the walkways and stairwells will be busy; people going to sign on, or collect the bru. Women scrub the concrete patch outside their front door. People gather in groups and talk about the early morning events. Who was lifted? Whose home was wrecked? How bad was the damage? What they said to the Brits, what the Brits replied, this and that.

He has disappeared, perhaps for seven days, perhaps for life.

Trisha Ziff, extract from 'Dawn Raids' *IRIS Magazine* No. 12

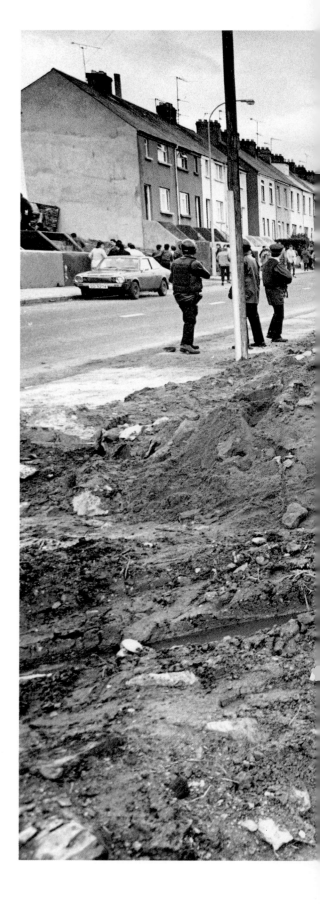

Arrest, Easter Sunday, Derry, 1987

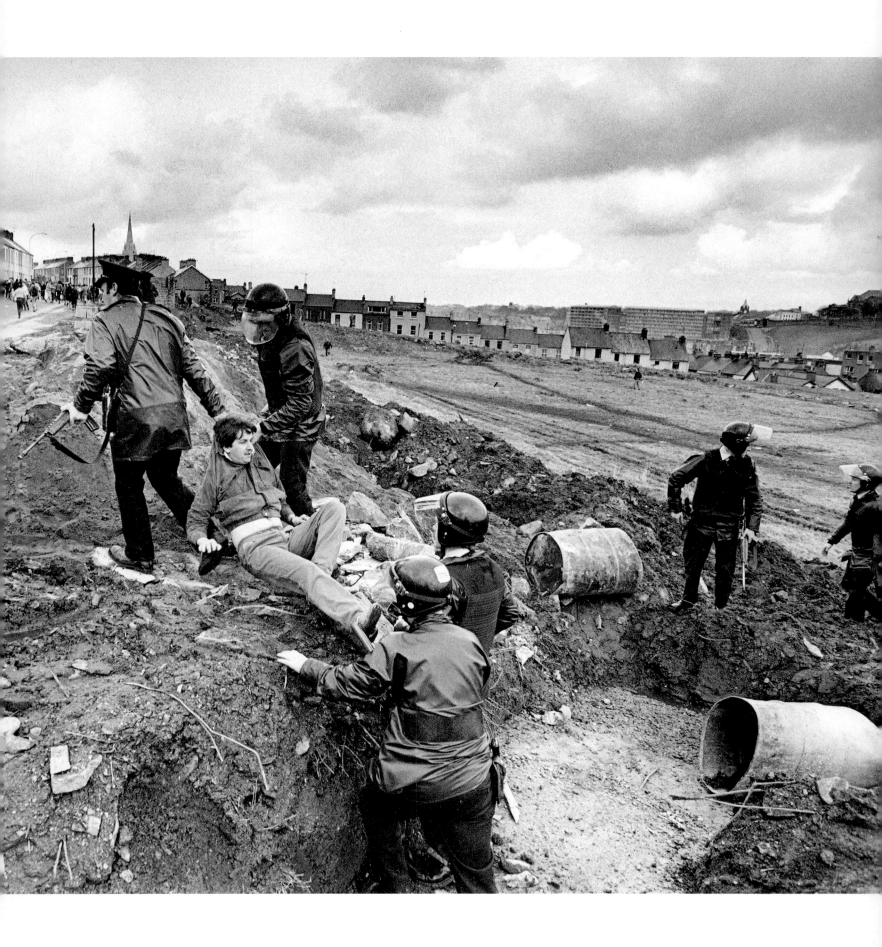

... I was more concerned at the time that I didn't miss more than anything else, I don't remember being scared. Everyone rioted, the most important thing was a hit. Then I got lifted and then I was sent to St Pat's. The Brothers weren't so bad. The food was rotten though, and once I ran away but ended up back there again. We were all just wee boys, and the worse thing of all was things happening on the road, marches for the 'H' blocks and the hunger-strike and not being able to go.

Extract from an interview with Martin
(Martin spent a year as a young offender in St Patrick's Training school.)

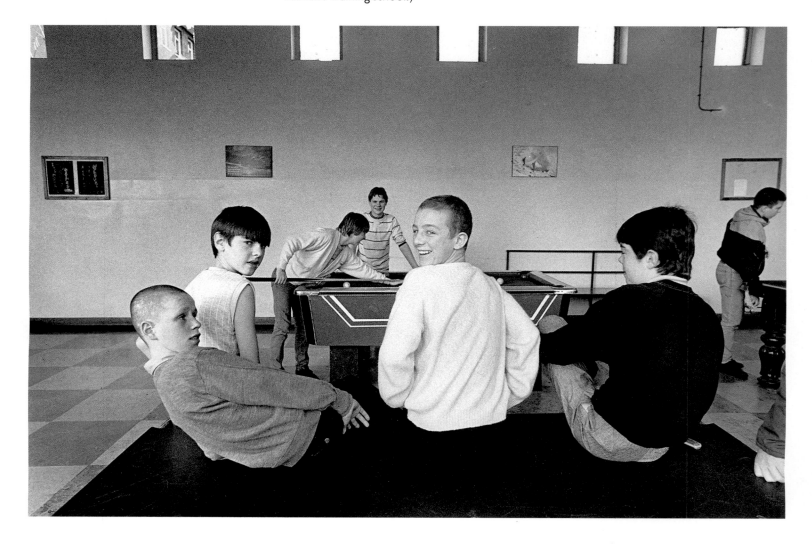

'St Patrick's Training School' for young offenders, run by the de La Salle Brothers, Andersonstown, West Belfast

All photographs stopped after I was sixteen. I don't reappear in the family album till I am thirty-one. In that interim period my identity was a sequence of numbers: 529. In the only photographs taken of me, I held a board in front of me with my new description. Once I smuggled one of these pictures out, even that was a precious image. I had a skinhead, it was after the 'No-Wash' protest, we all locked suddenly so different so they made new pictures for our new identities. I remember after four years of not cutting my hair I couldn't recognise this clean shaven person as me. It felt very strange. I knew the photograph was me from the number, although I knew the number was never me. The first thing that happened to me on my release was that I had my photograph taken with my family and friends.

Jack McGarry, released POW having served thirteen and a half years in gaol

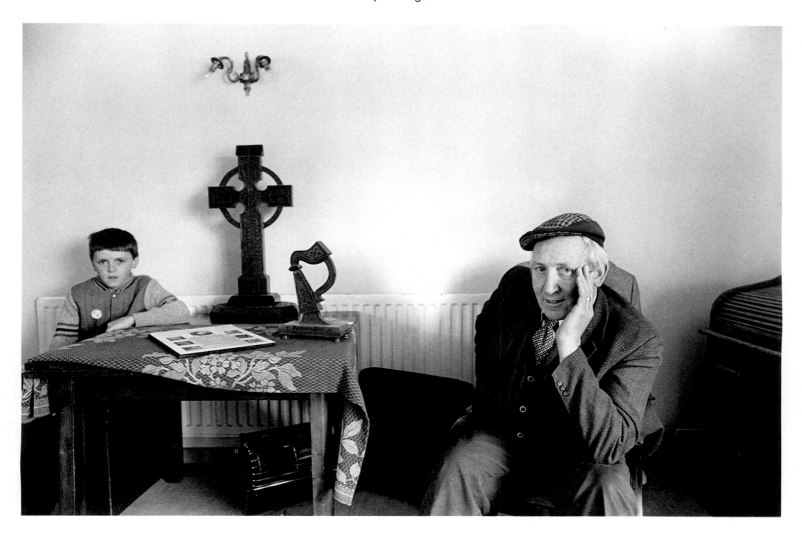

Cullyhanna interior. The cross was made in the Crumlin Road Gaol, Belfast, and the harp in Portlaoise Prison in the south of Ireland

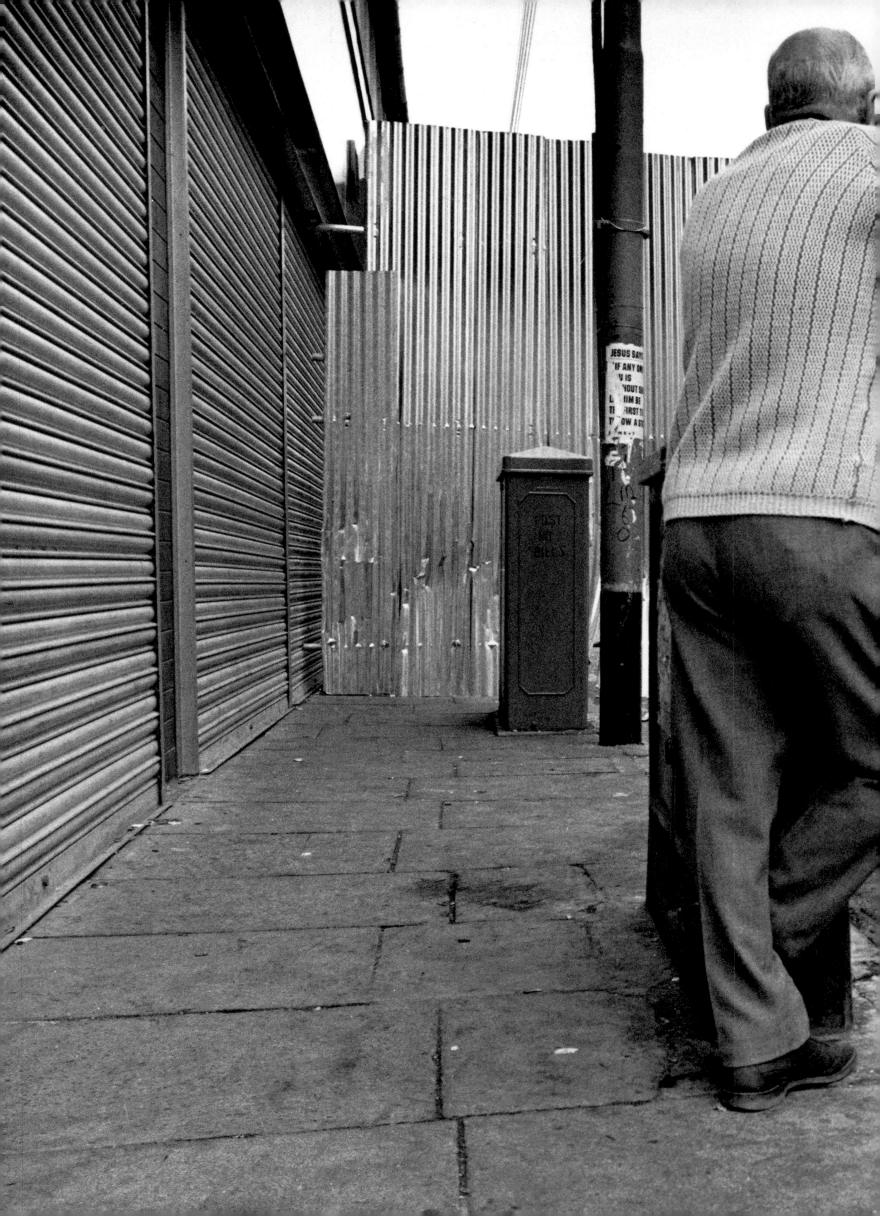

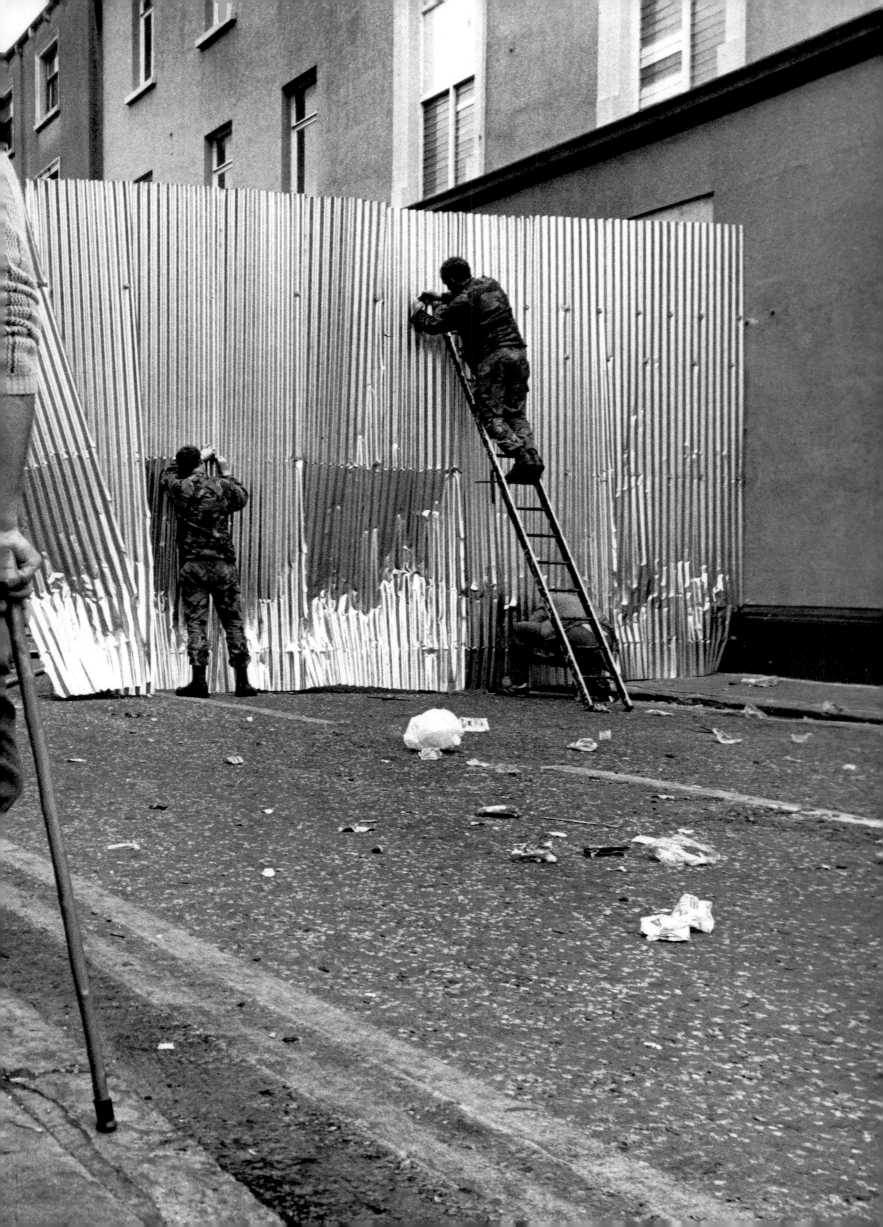

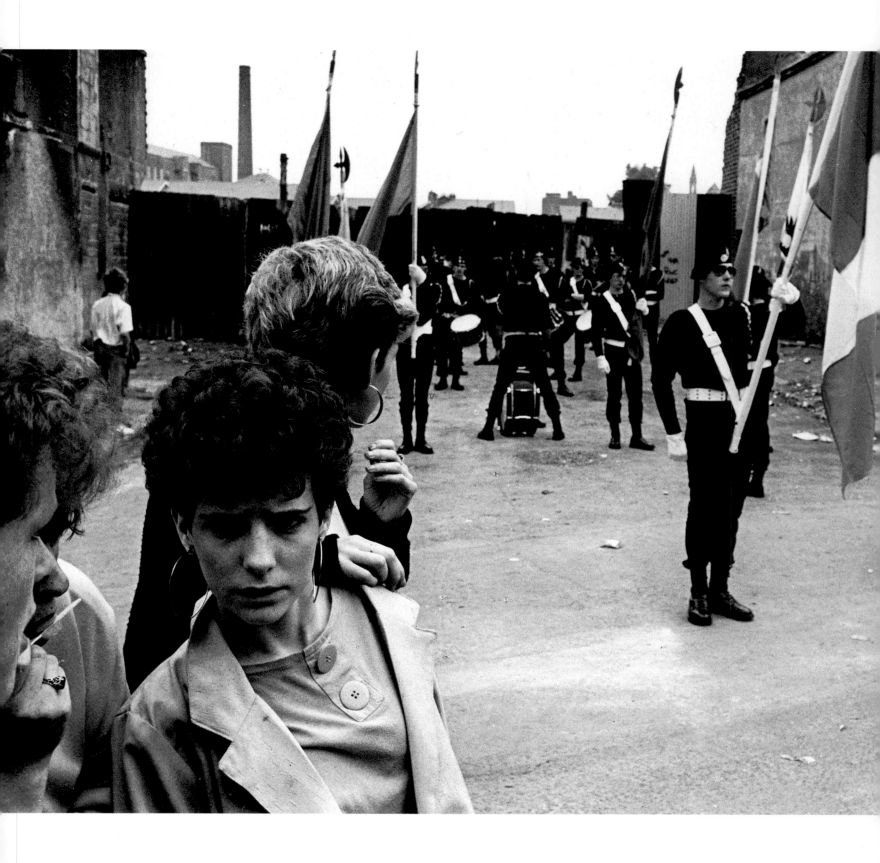

Republican youth bands practice while waiting for the Internment Commemoration March to begin, Falls Park, Belfast, 1987

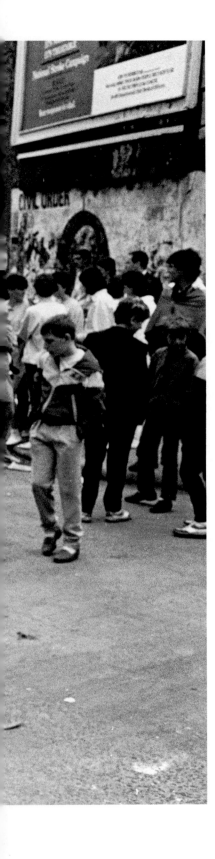

MARCH

There was a time when it felt that all we did was march. First we marched for civil rights, then we marched against Internment. We marched to remember Bloody Sunday, and we always marched at Easter. We were always on the road, marching for political status, marching against the conditions in the prisons, marching for the hunger-strikers. Then we marched against strip searching, plastic bullets, and paid perjurers. We marched to Armagh and now Maghberry for International Women's Day and we march each year in Bodenstown. Our marches were disrupted, attacked. We were shot at, women and children, whoever, indiscriminately, point blank. In 1985 at the Internment March, John Downes was shot dead at the Busy Bee. We saw ourselves on TV that night – the event recorded by the media. Shot at point blank range with a plastic bullet. He left a young wife and a baby. I shall never forget her screams when the priest broke the news to her in the casualty department of the Royal, nor the smiles on the RUC faces who were arresting the injured for illegally marching.

Mary, member of the Relatives Action Committee

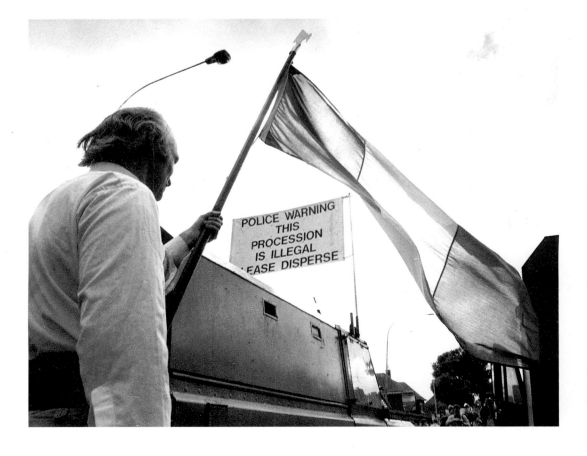

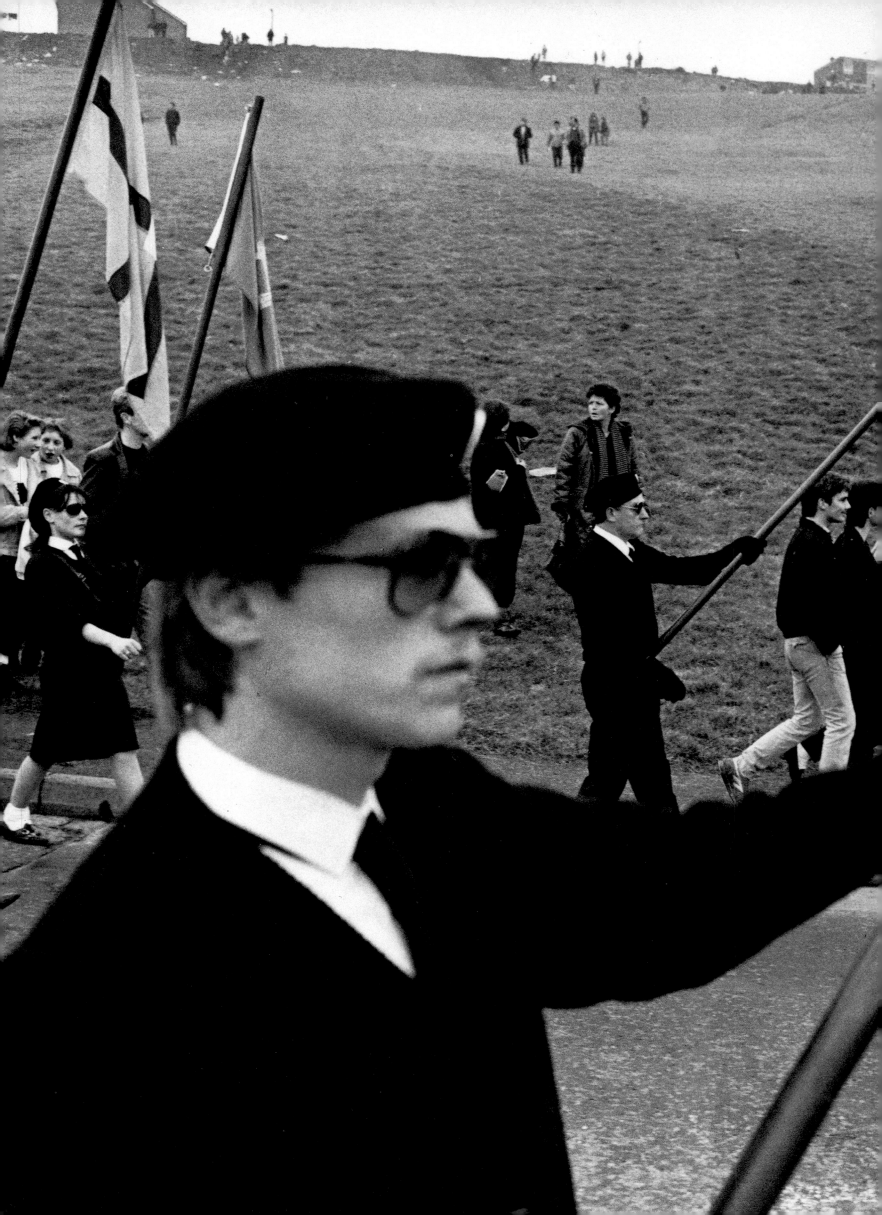

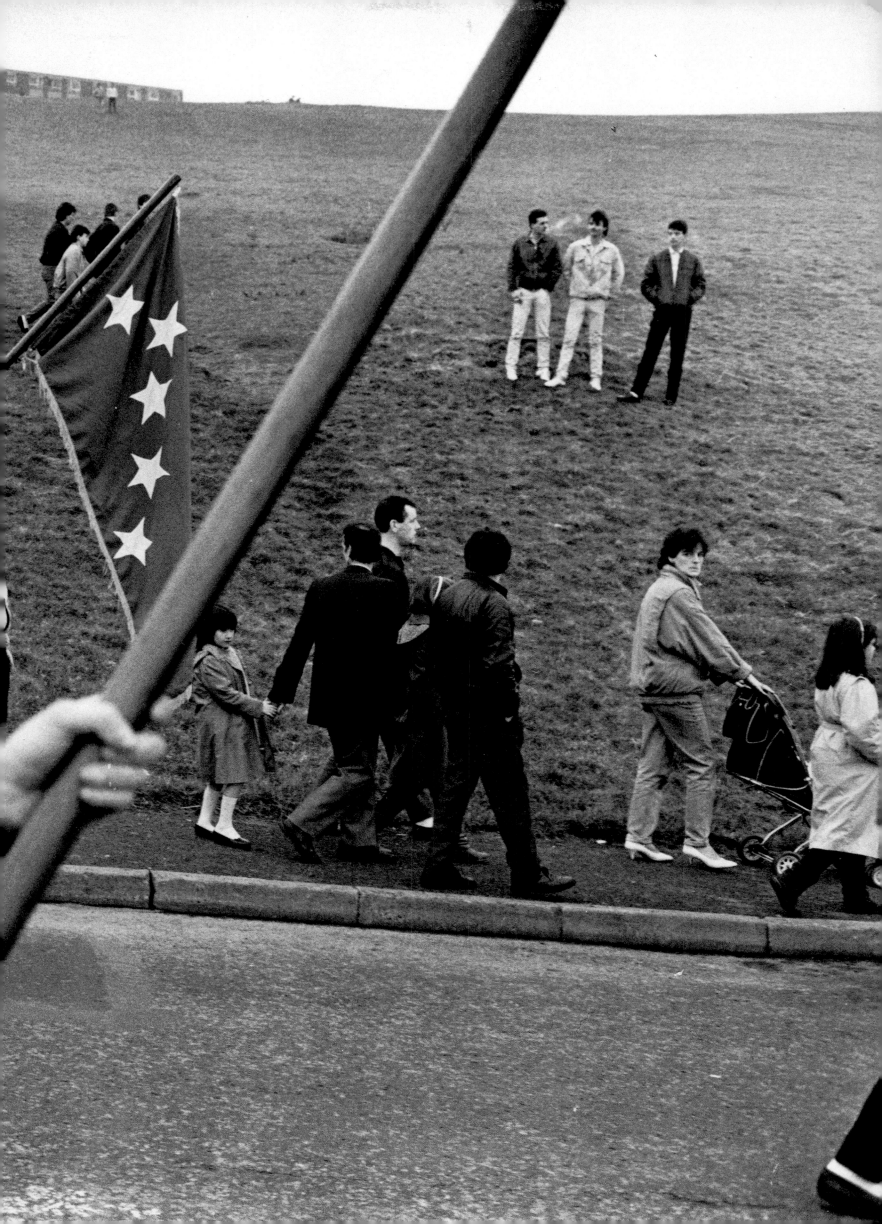

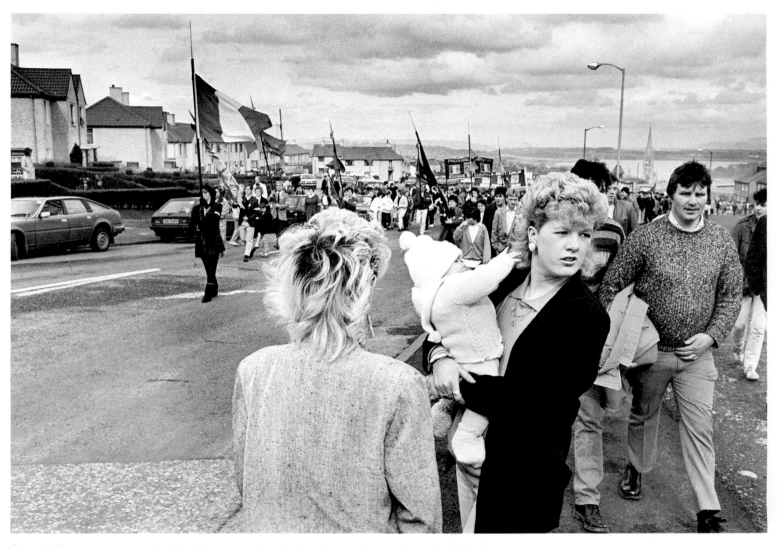

Easter 1987, commemorating the 1916 Rising, when the Irish Republic was first proclaimed in Dublin. Creggan, Derry

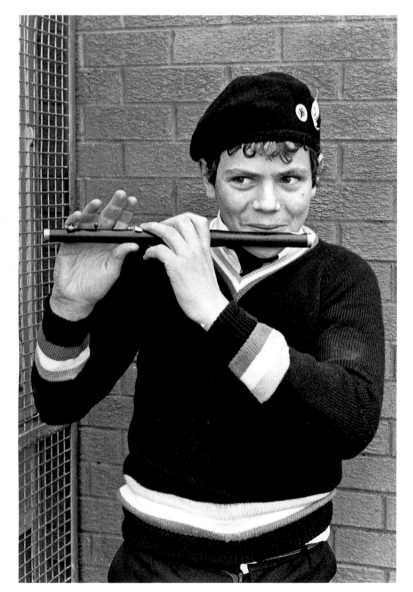

I joined a band mainly because I like to play music; it's also part of my culture, of being Irish. For centuries we were robbed of our langauge, persecuted for our religion, so for me playing in a band is an expression of who I am. Each band has its own identity, some are named after a volunteer from the district who was killed, ours is called the Patsy O'Hara Band, named after the hunger-striker. There's not much chance of a job after school, playing is an important part of my life. The Brits think we're young provos, but it is not an offence yet to play the flute in a band.

Interview with a member of a band

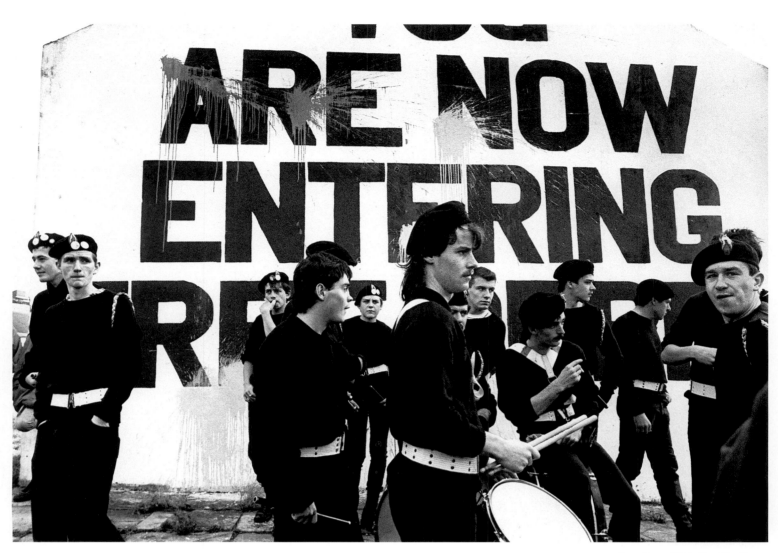

Free Derry Wall, Bogside, Derry

John 'Caker' Casey, who by dint of his dab hand with a paint brush was recognised as an expert wall-sloganeer, fetched out the tools of his trade and in a moment of inspiration wrote 'You are now entering Free Derry' on a gable-end in St Columb's Street.

Eamonn McCann, *War in an Irish Town*

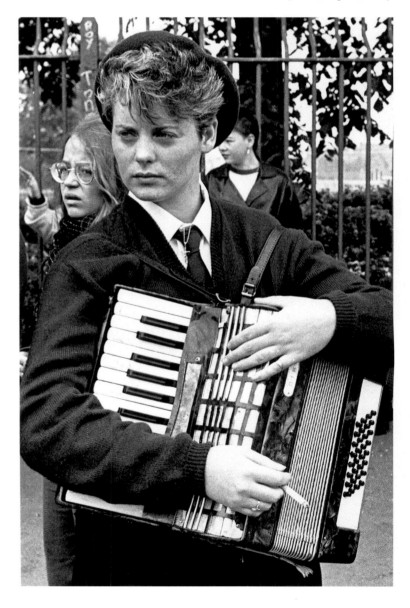

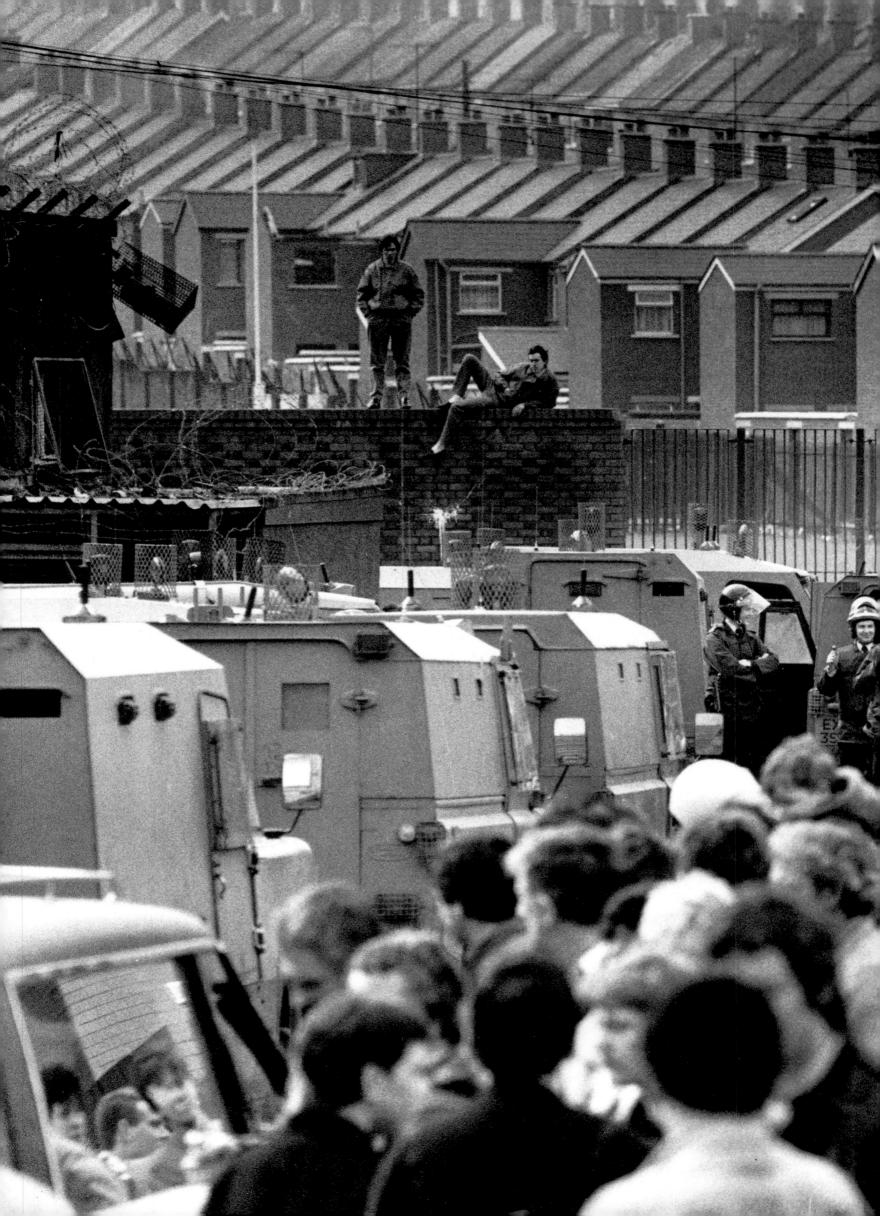

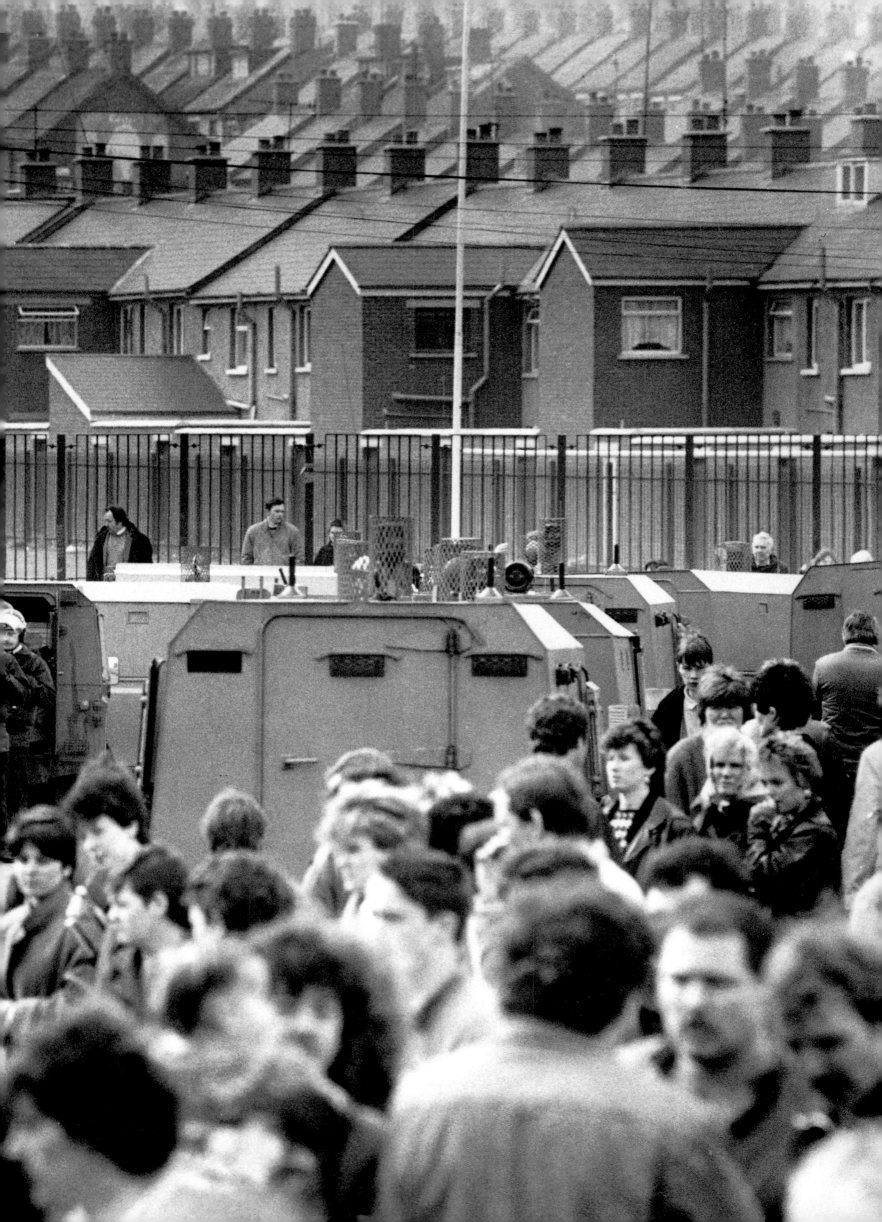

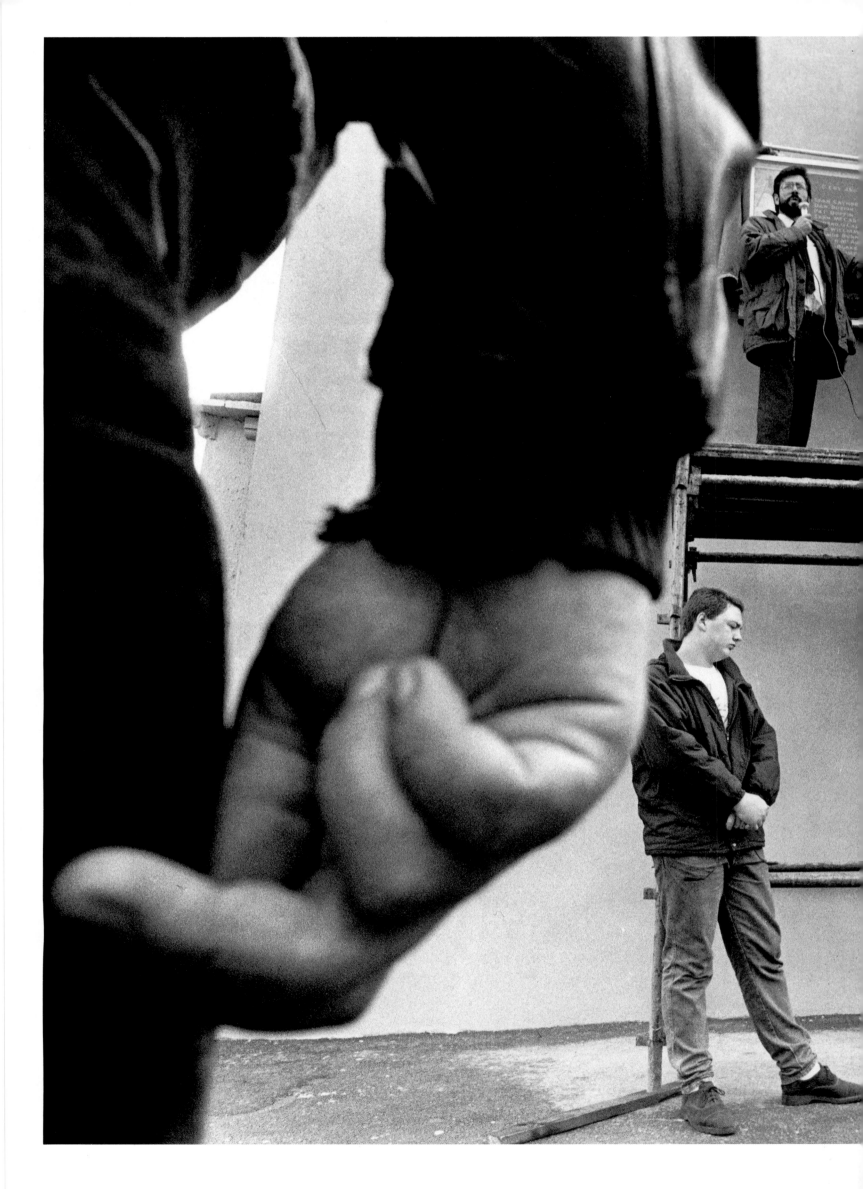

Gerry Adams MP, President of Sinn Fein, unveils a plaque to the IRA dead, Kashmir Road, West Belfast

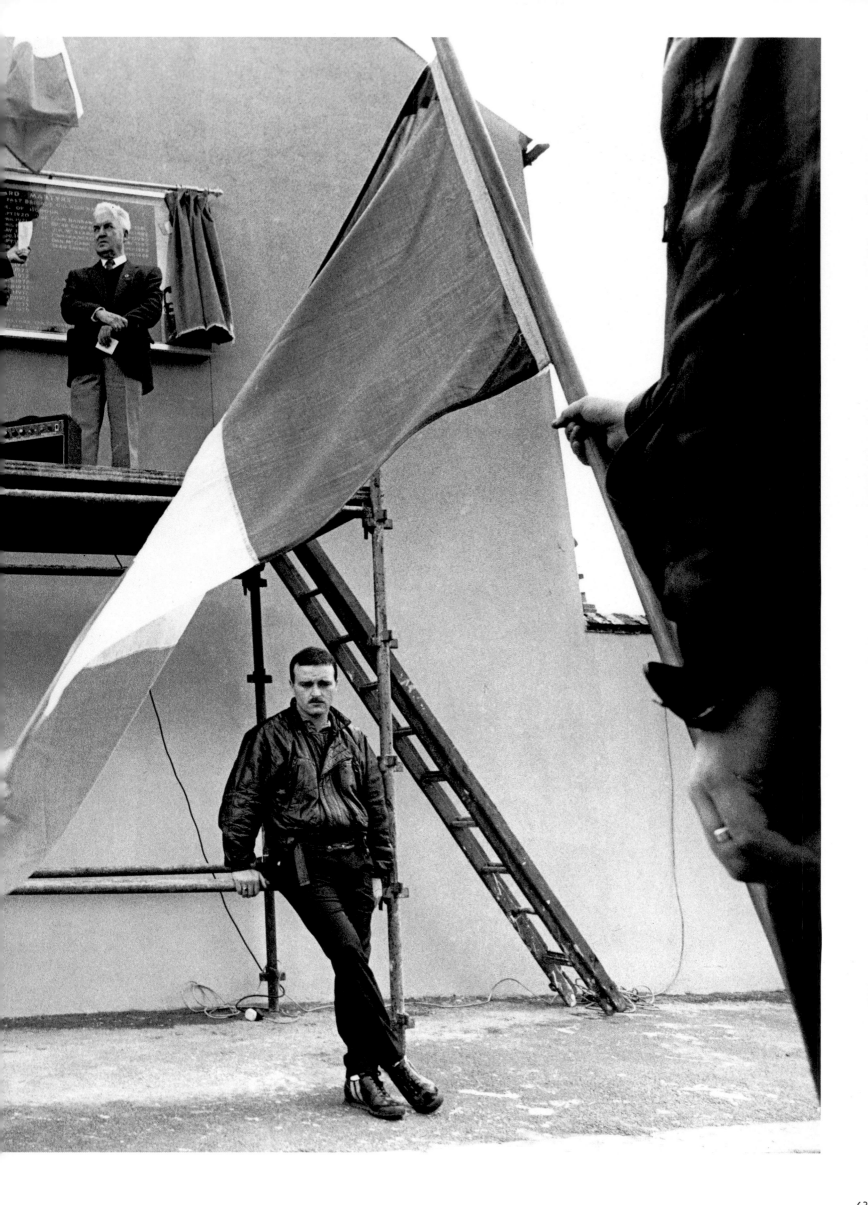

CHURCH

Whenever the clergy succeeded in conquering political power in any country the result has been disastrous to the interests of religion and inimical to the progress of humanity. From whence we arrive at the conclusion that he serves the religion best who insists upon the clergy of the Catholic church taking their proper position as servants to the laity and abandoning their attempt to dominate the public, as they have long dominated the private life of their fellow Catholics.

James Connolly, *Labour Nationality and Religion,* 1910

During the mass at St Patrick's chapel, Crossmaglen

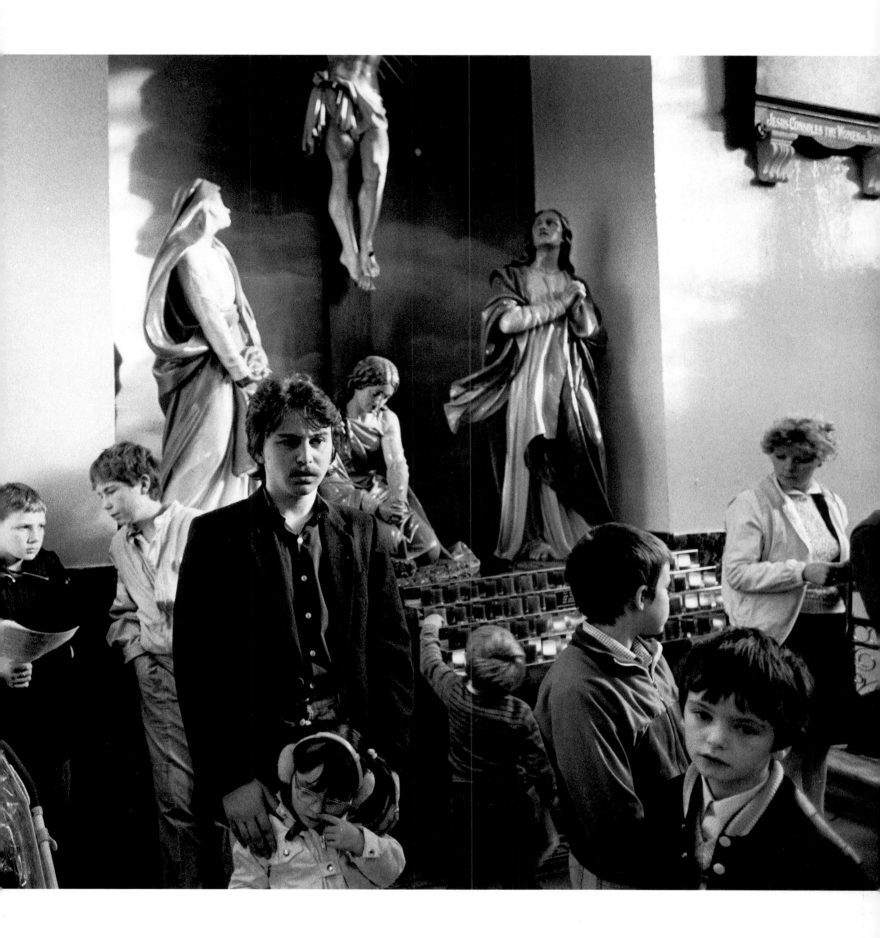

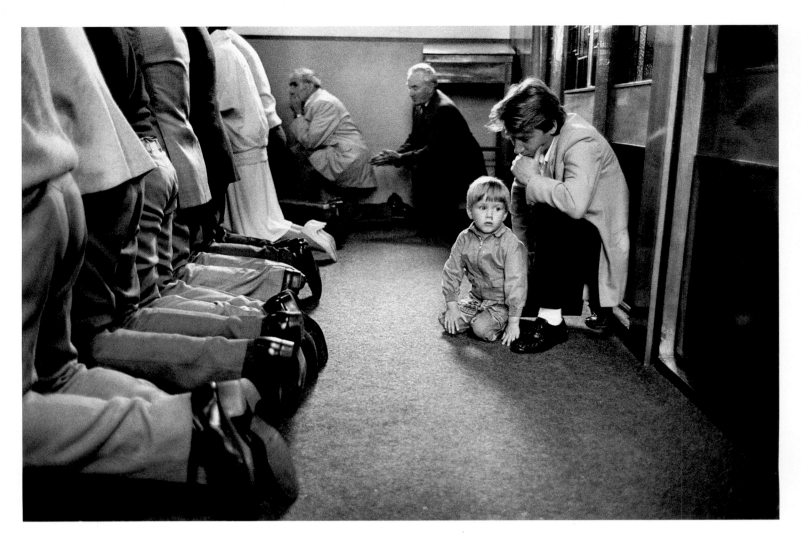

Chapel of the Holy Cross, Ardoyne, North Belfast

First communion, Long Tower Chapel, Derry

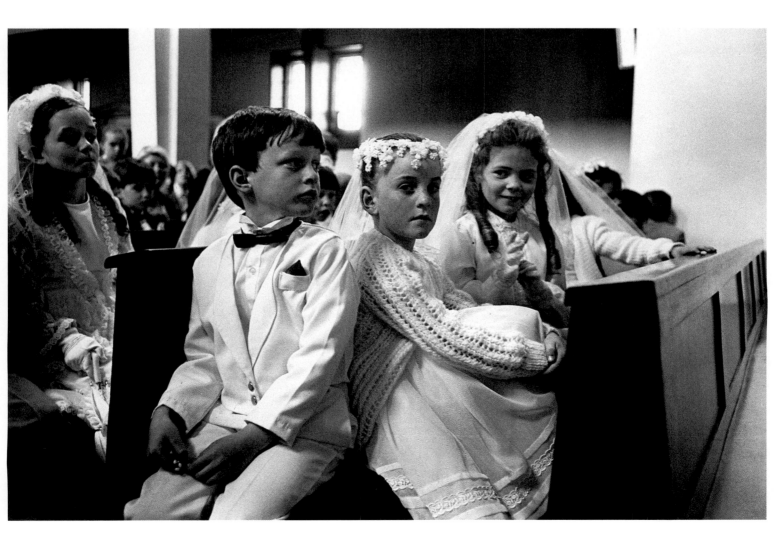

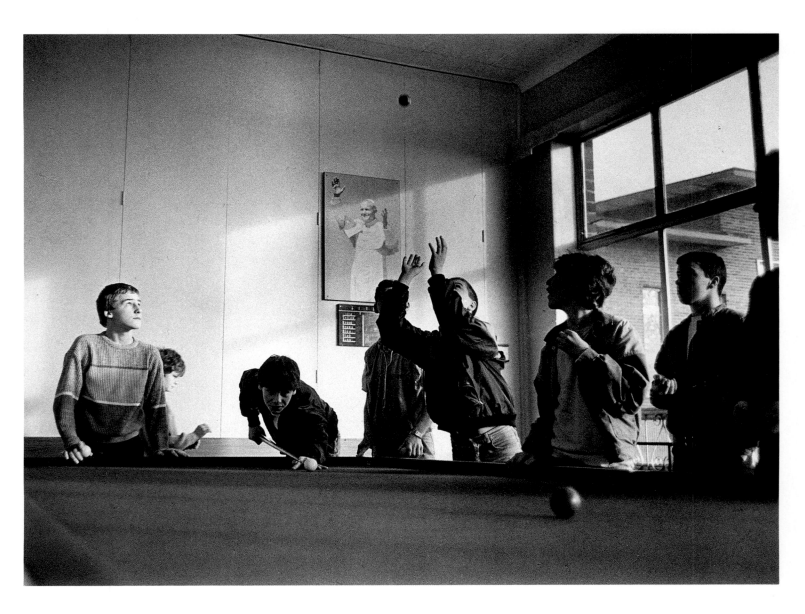

The Pope plays ball, St Patrick's Training School

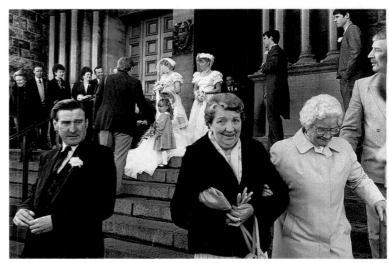

Mass, Crossmaglen, South Armagh

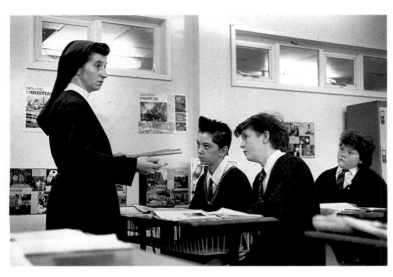

St Louise's Comprehensive College, Falls Road, Belfast

After first communion, Bogside, Derry

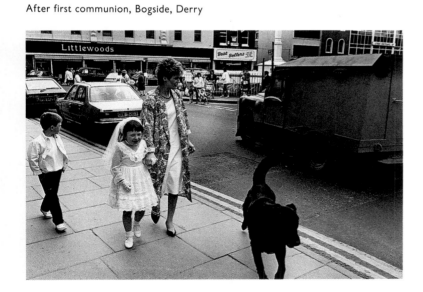

Wedding, Ardoyne, North Belfast

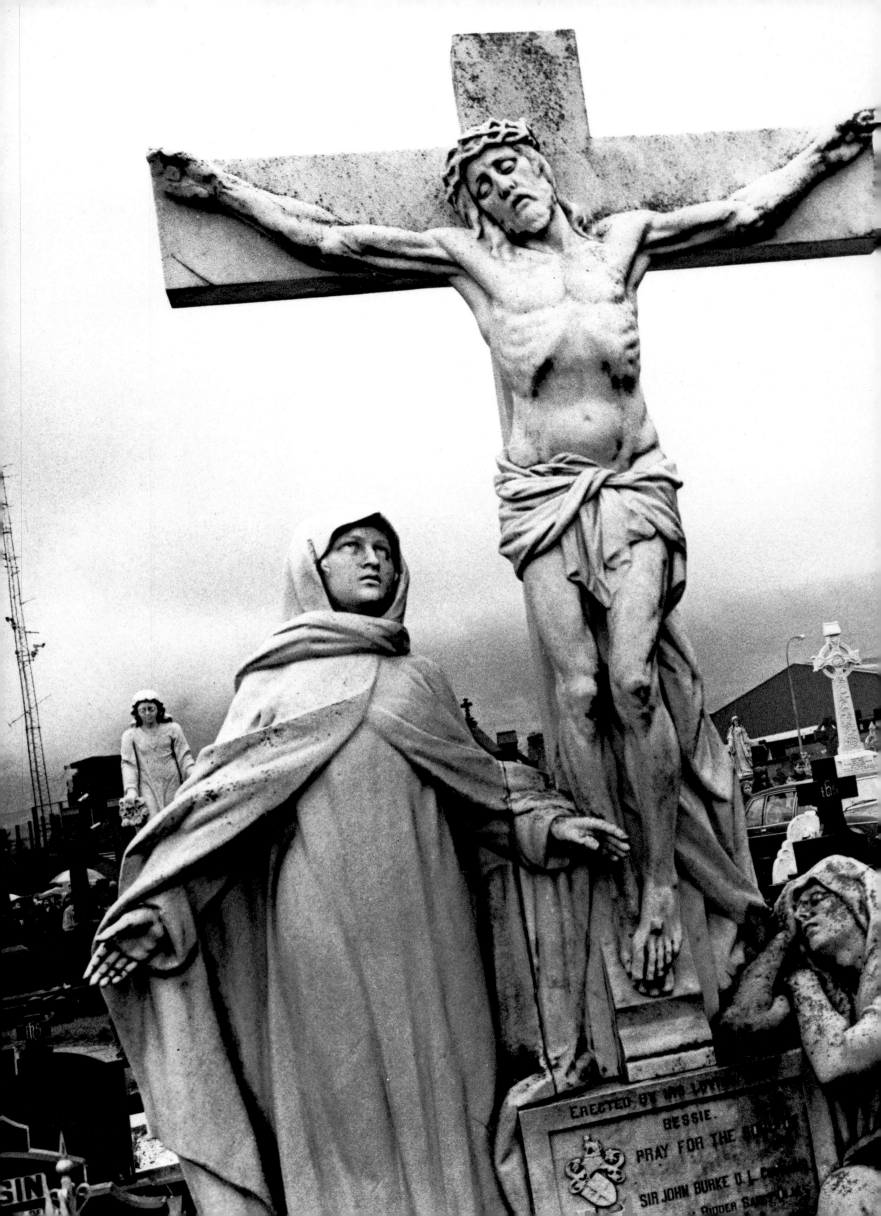

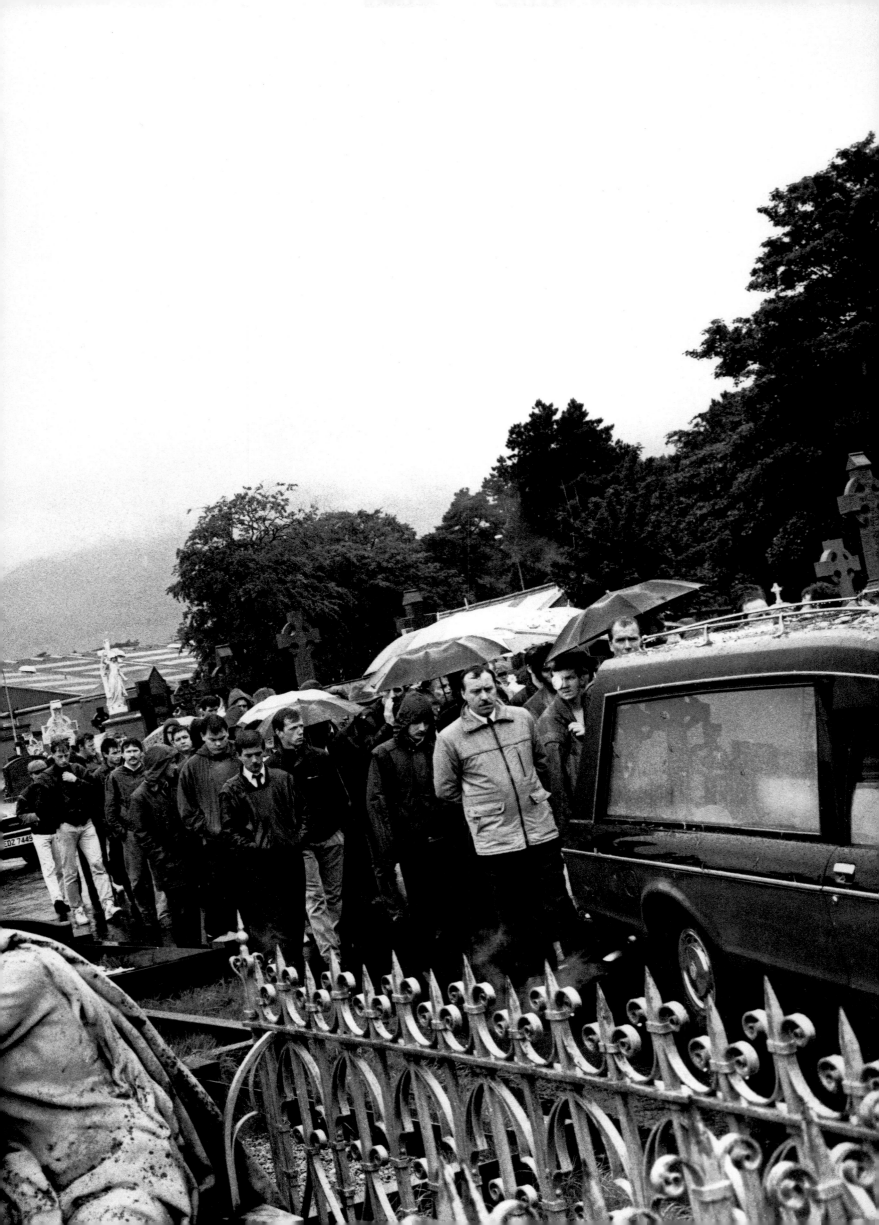

CHILDREN

It occurred to me one day that my son, who is about to be married himself, didn't remember a time when the Brits weren't here. To him the situation was normal. How do you explain that it could be different? We never imagined that it would go on so long. When he was a lad we imagined that it would all be over before he grew up. Now I am not so sure his children will be free of it. You worry for them – it's not a place for young people to grow up, not safe to play. Look at how many children have been injured by plastic bullets. Then there's the joy riding. I've lost my taxi a couple of times. No, it's not a place for young peole to grow up, not now at any road.

Conversation with a taxi man on arriving in Belfast.

Playing near the 'Peace Line', Bombay Street, West Belfast

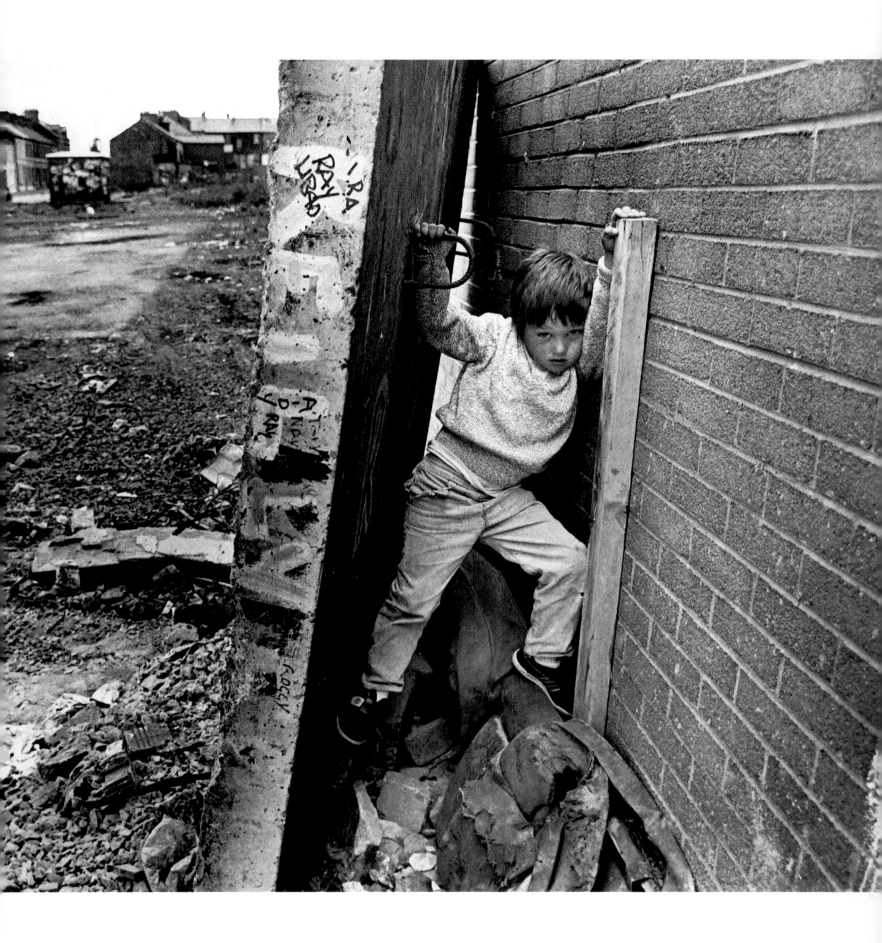

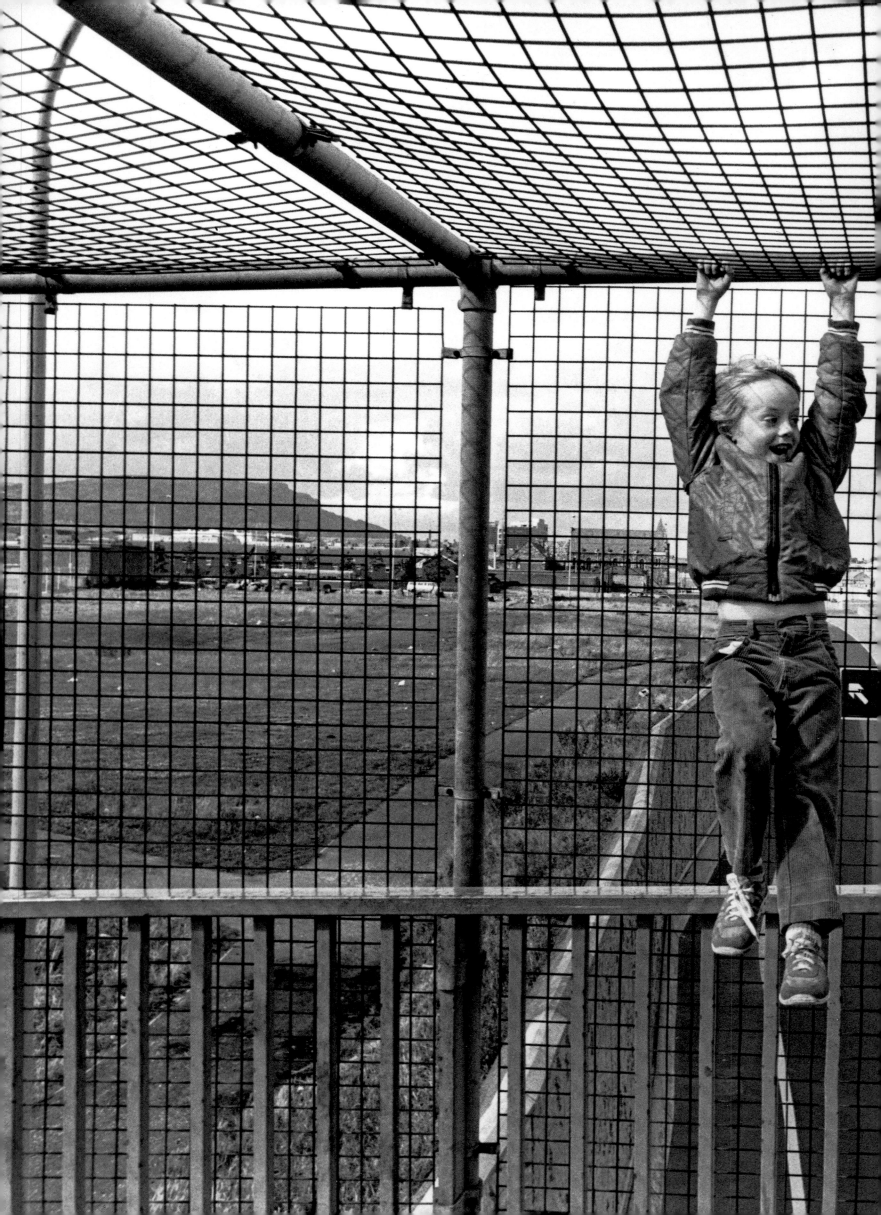

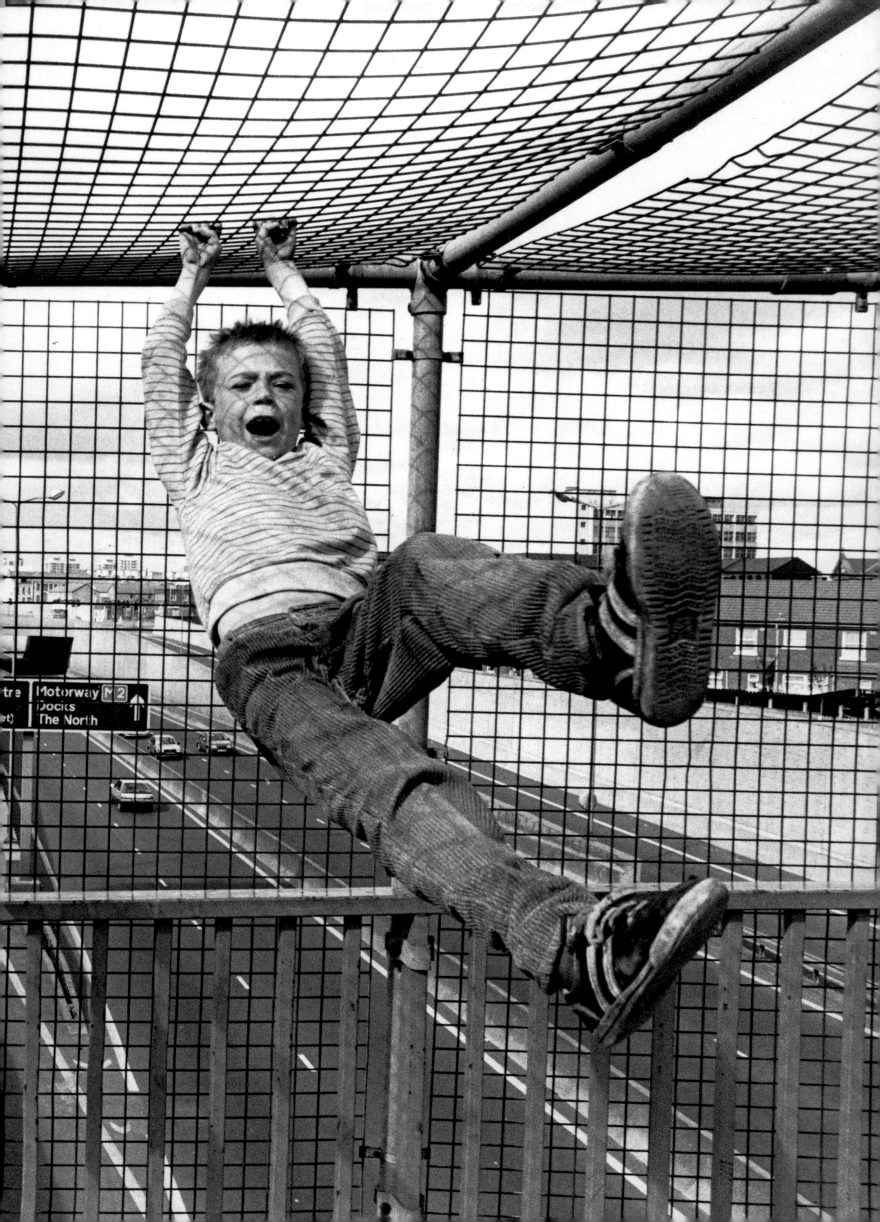

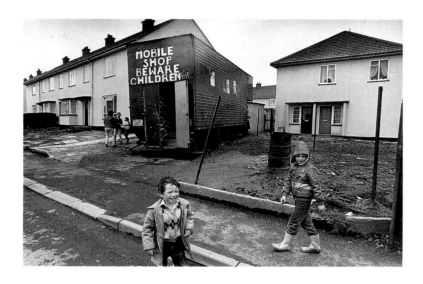

Mobile shop, Creggan, Derry

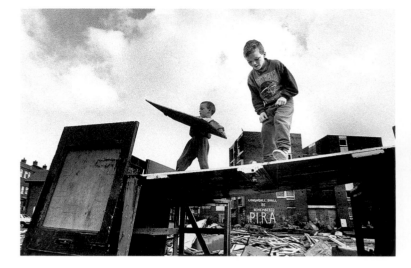

Building a bonfire, New Lodge

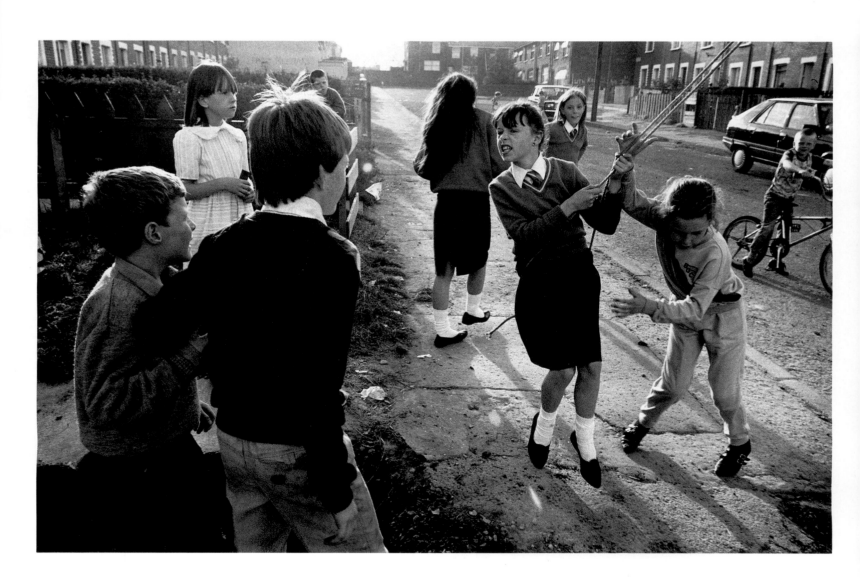

Street games, Ardoyne, North Belfast

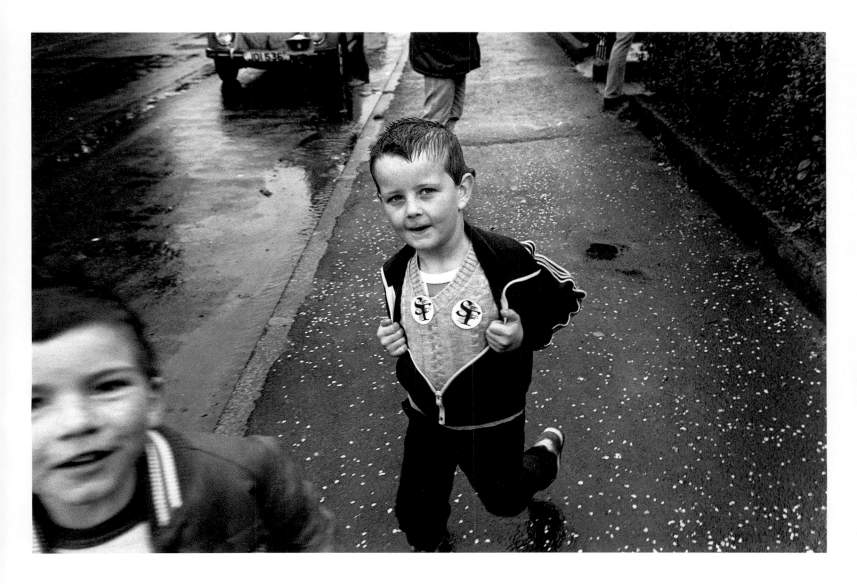

'Vote Sinn Fein', General Election 1987

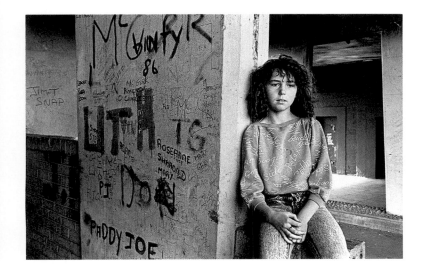

Girl, Divis flats, West Belfast

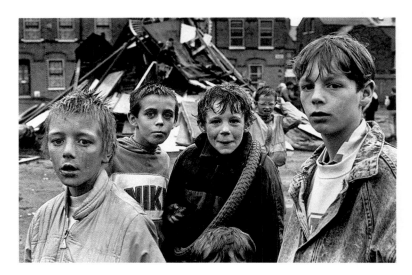

Collecting for Internment Commemoration Bonfire, New Lodge

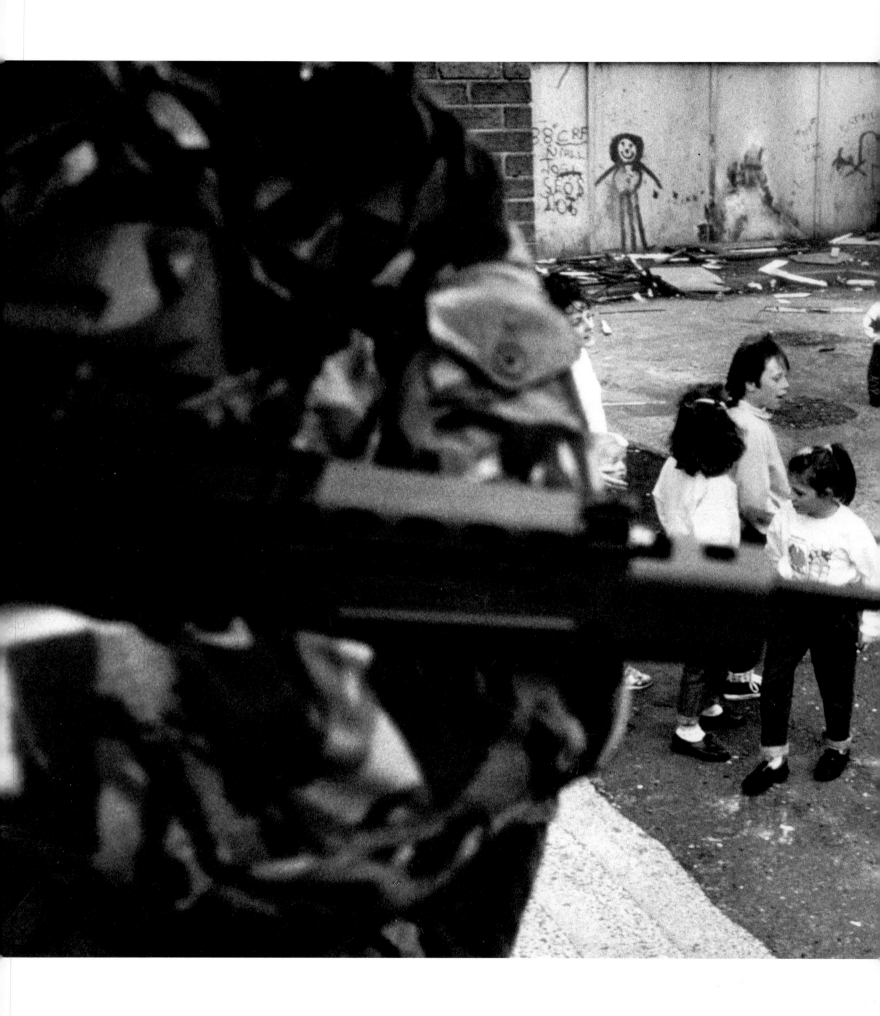

British Army foot patrol, 'Peace Line', West Belfast

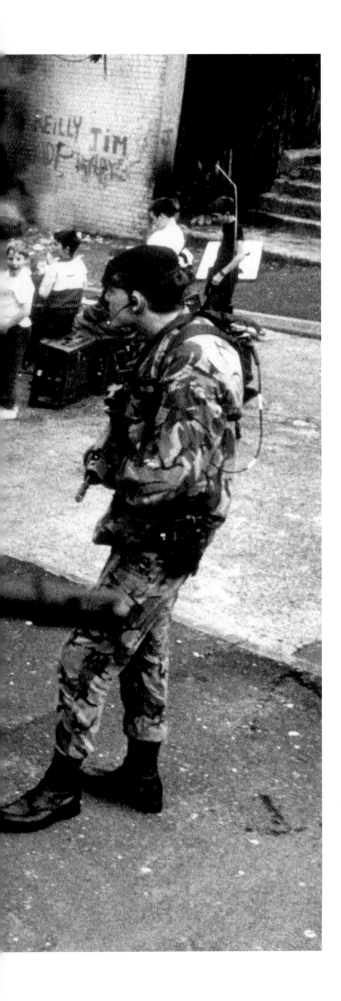

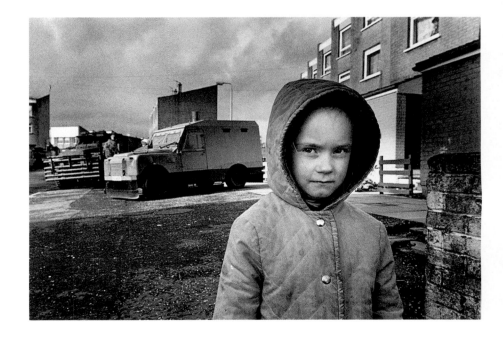

Leaving for school during an army and RUC raid, Springhill Estate, Belfast

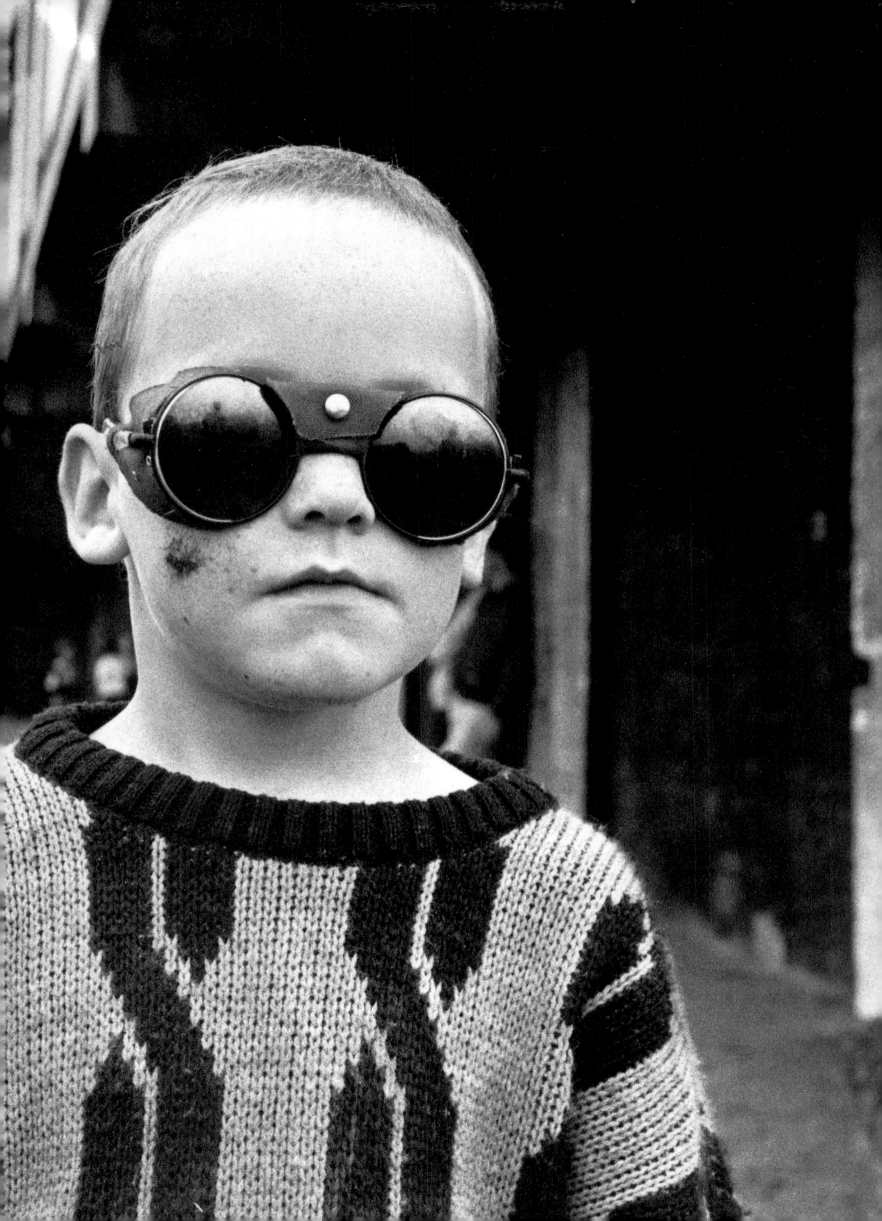

WALLS

The murals came about during the hunger-strike when young people wanted some way to show how they felt. It's more than just something to look at and something that lasts, and isn't just graffiti. It's a positive statement of our ideas. Even people who don't agree with the politics of the murals like them being there . . . of course the Brits come in and throw paint bombs at them at night, but we just paint them up again. Often at the end of a tour of duty a Brit patrol will stop and soldiers get their pictures taken alongside the murals as a souvenir.

Hawks, mural painter, Bogside, Derry

Welded-up door in the 'Peace Line', West Belfast

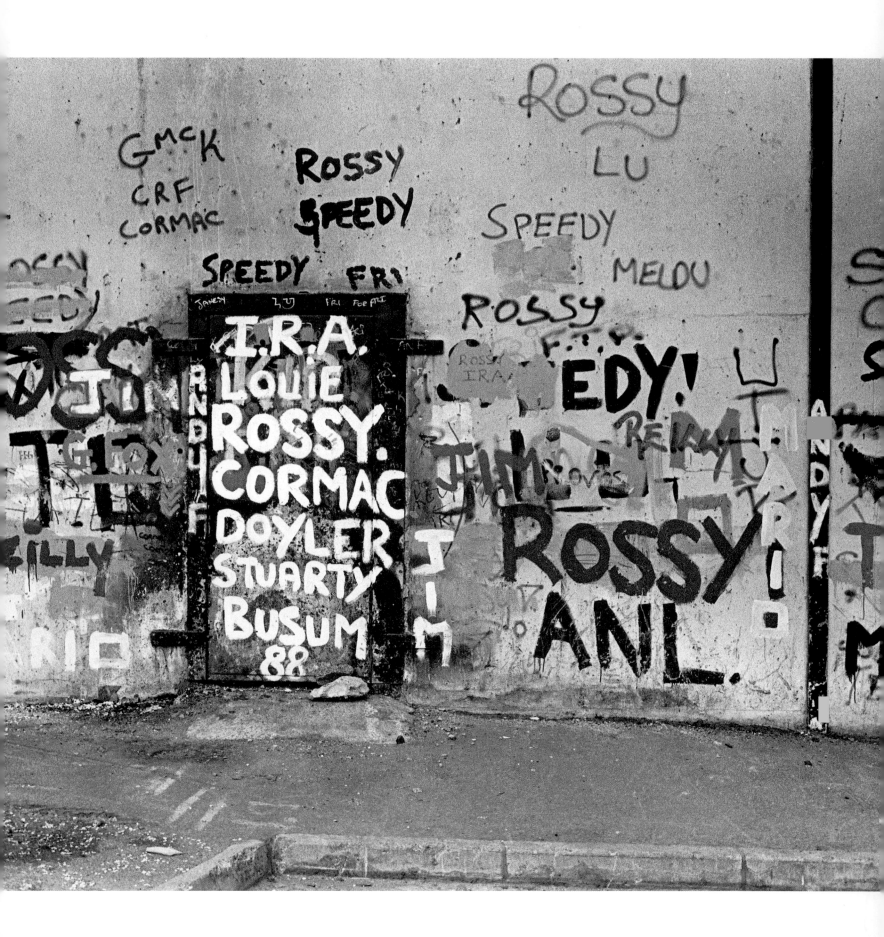

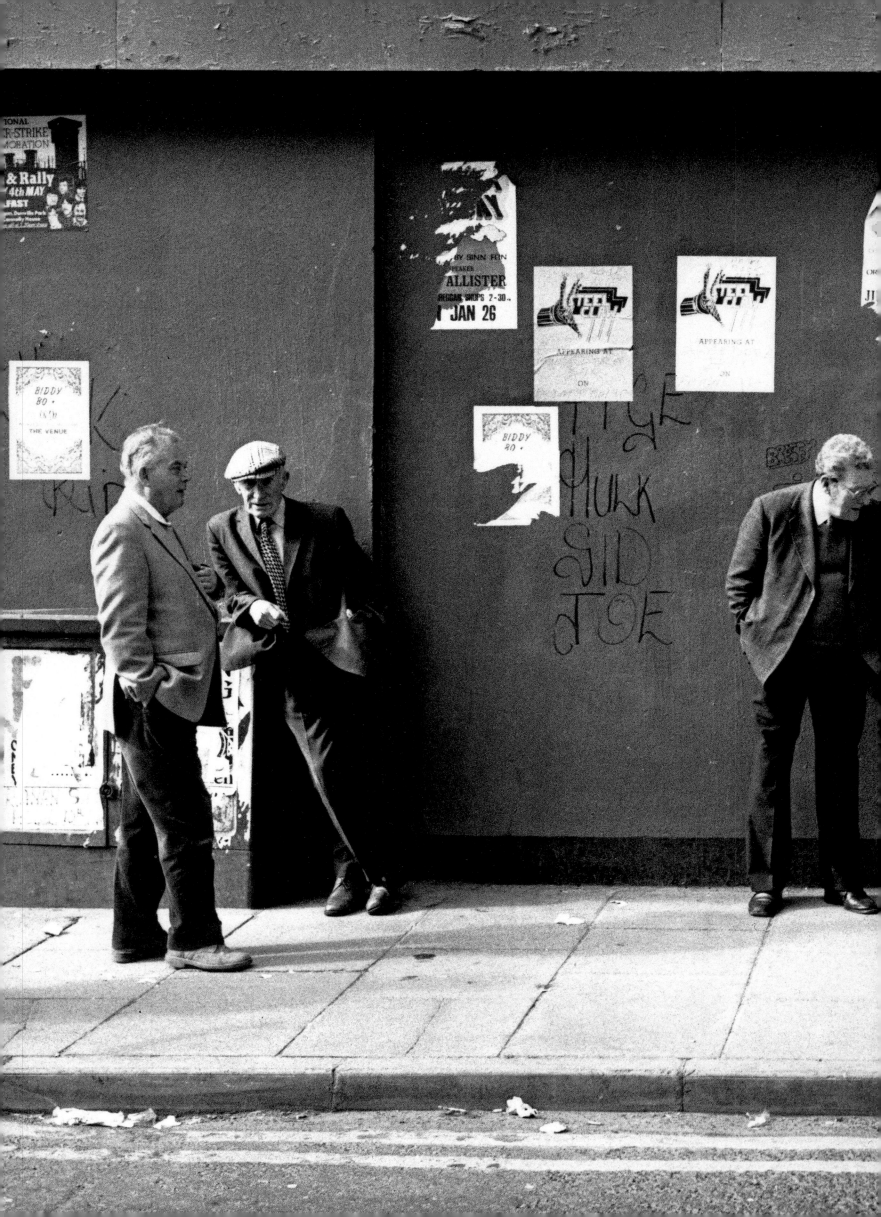

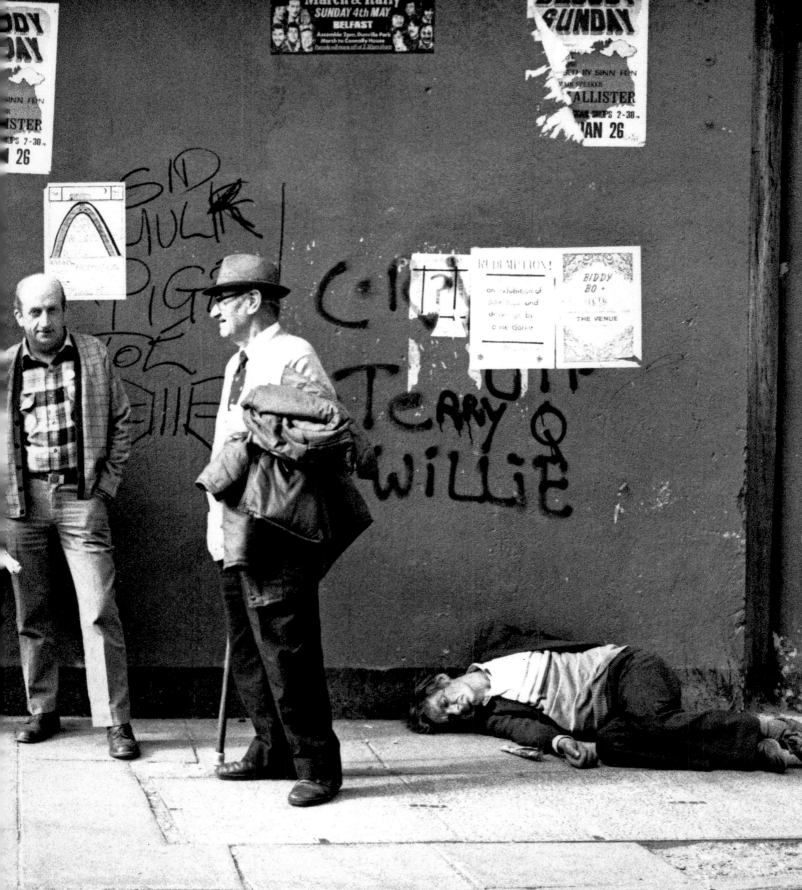

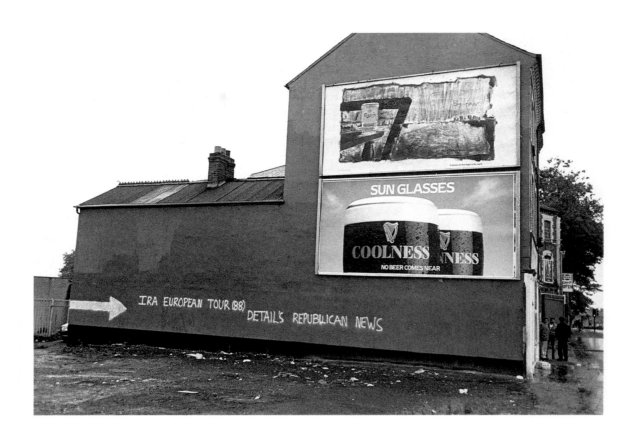

Guinness and graffiti, Belfast

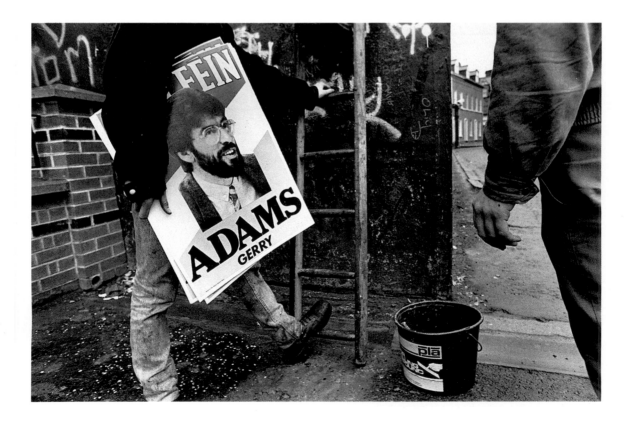

Sinn Fein election campaign, Belfast

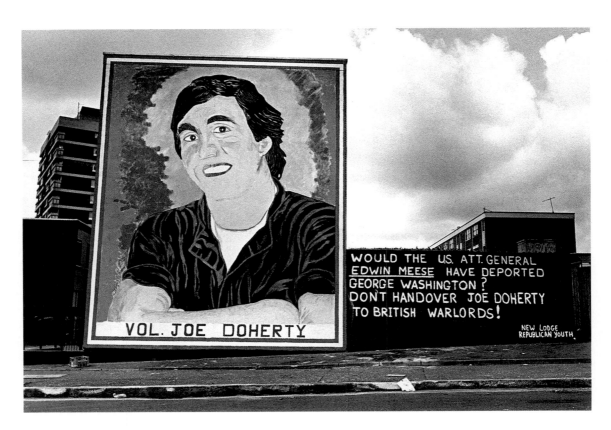

Mural to Republican Joe Doherty, held in the Manhattan Correctional Centre in New York since 1983 fighting extradition. New Lodge, Belfast

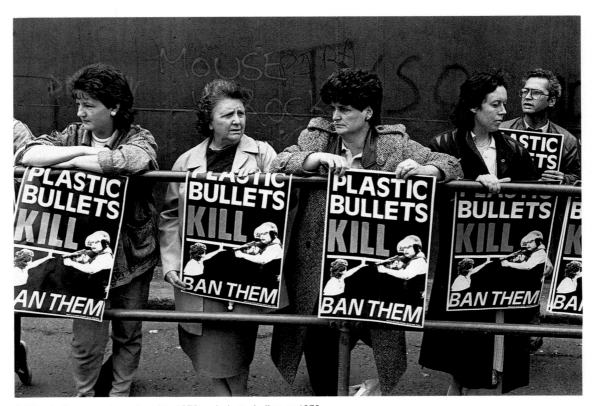

Rubber bullets were introduced in 1970 and plastic bullets in 1973.
Their use has resulted in the deaths of 16 people, 7 of whom were children,
as well as hundreds of serious injuries.

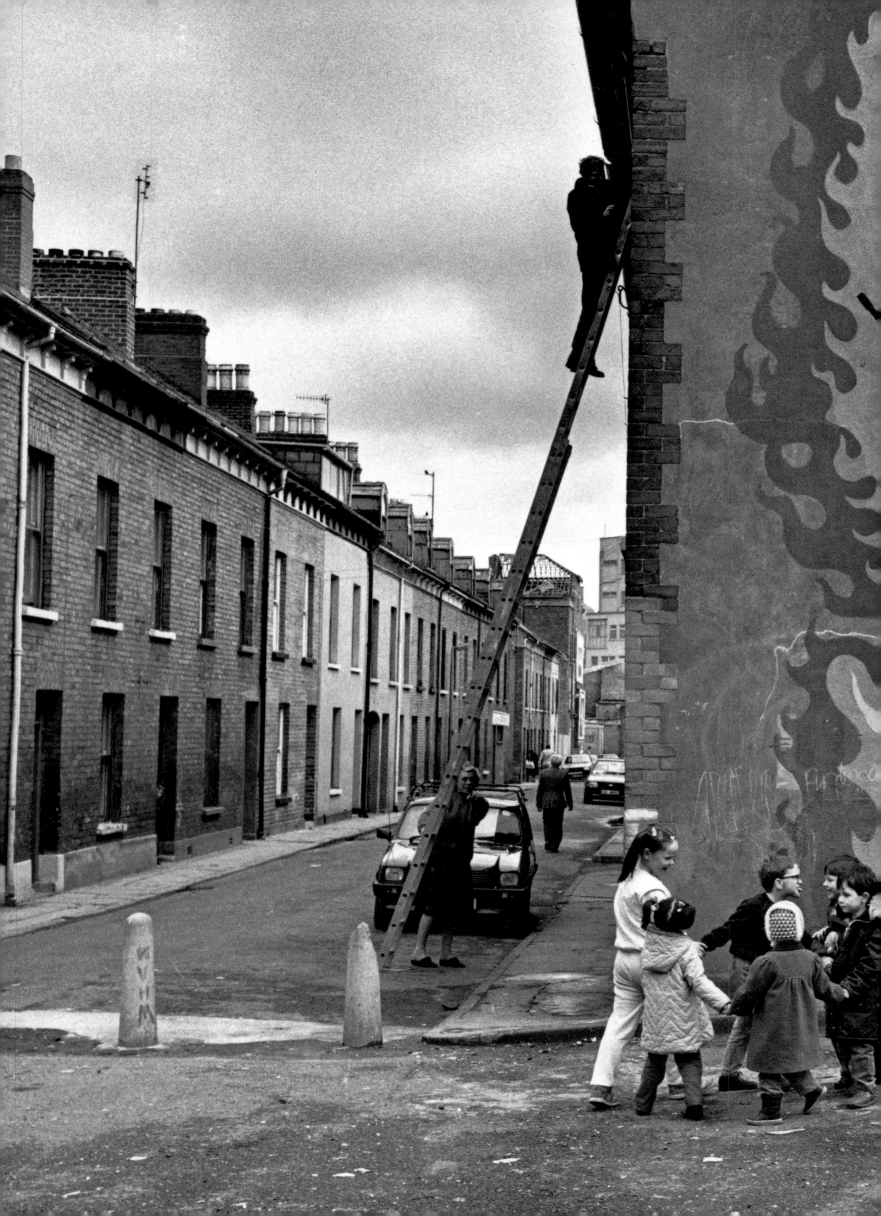

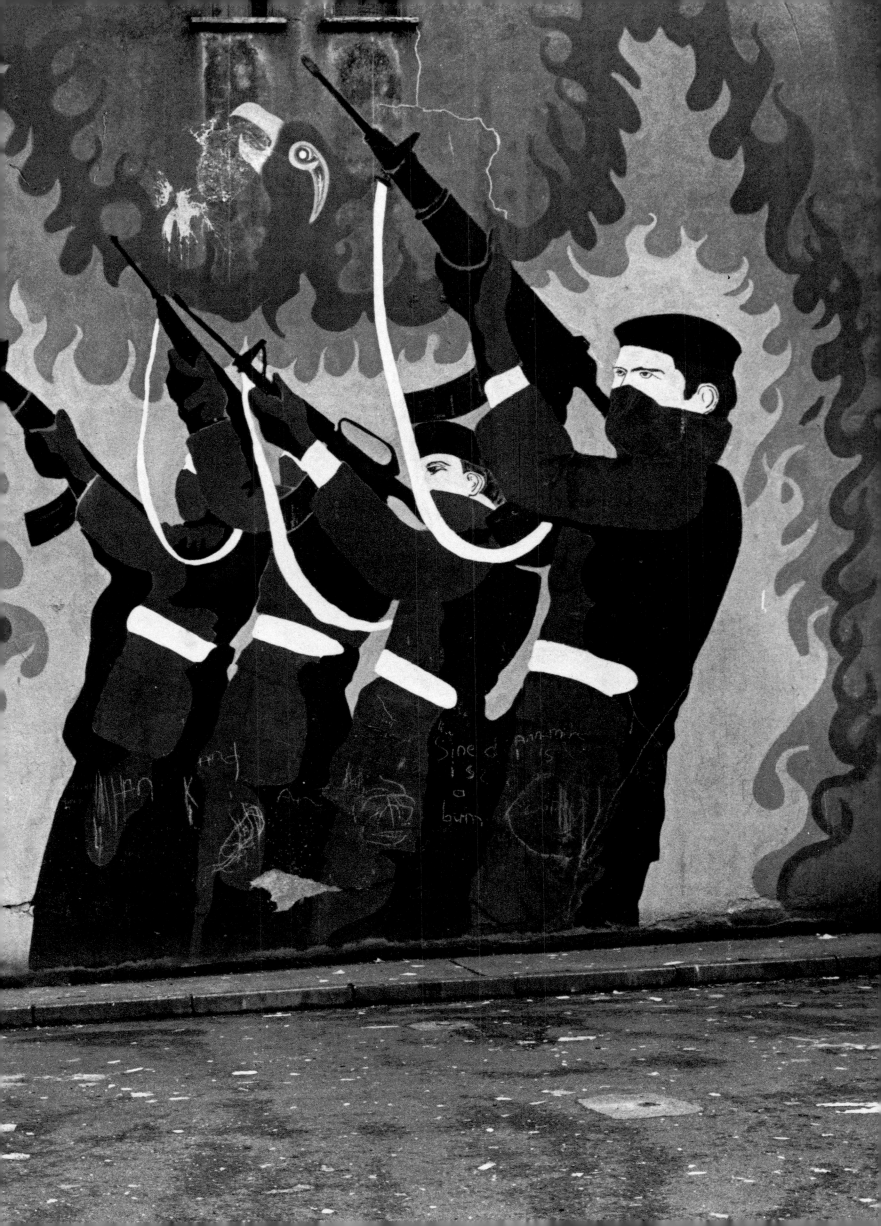

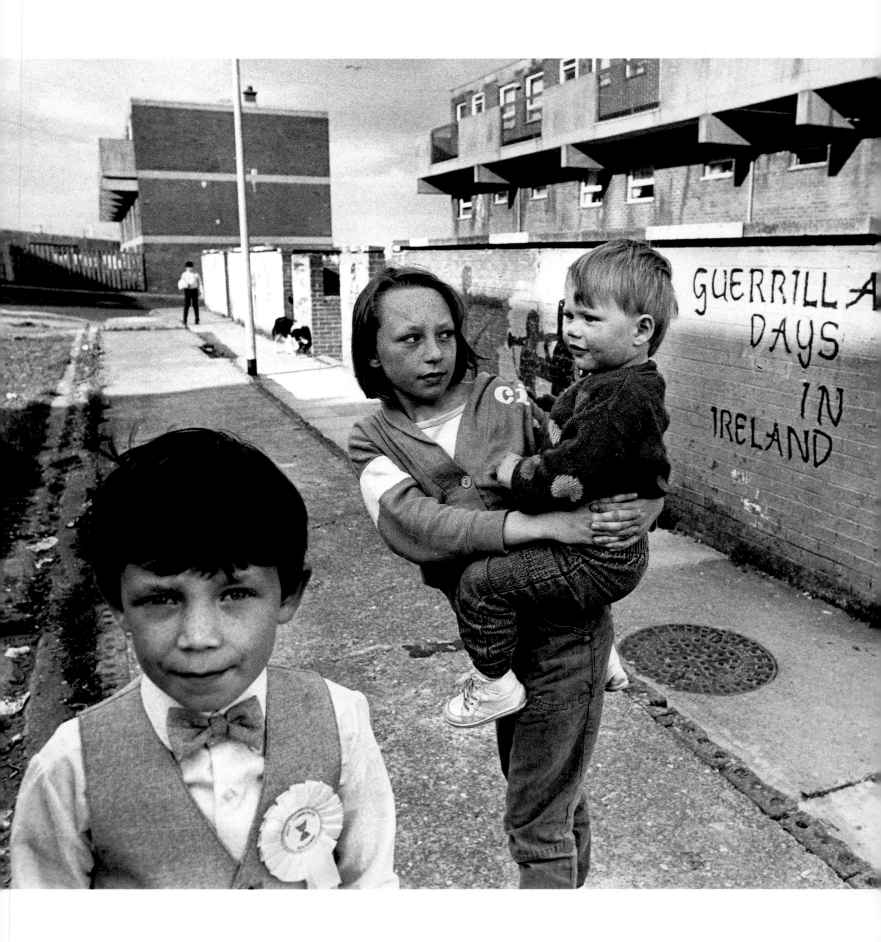

Creggan, Derry

GUERRILLA DAYS

We have a culture and we have a language, and no matter how much the Brits have tried to stamp it out, our language has survived. There are more ways than one of fighting a war. You don't just fight a war with a gun, there is also a war of words and pictures.

Julie Doherty, from the film *Picturing Derry*

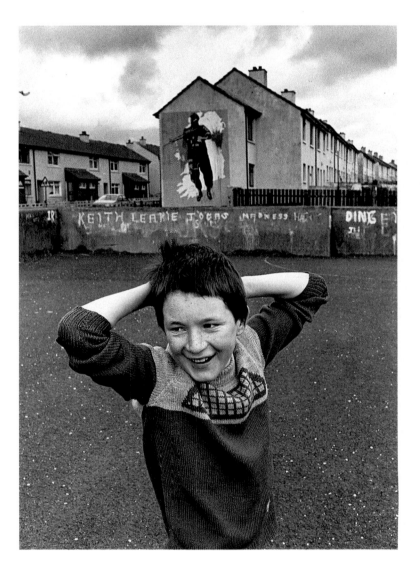

Creggan, Derry

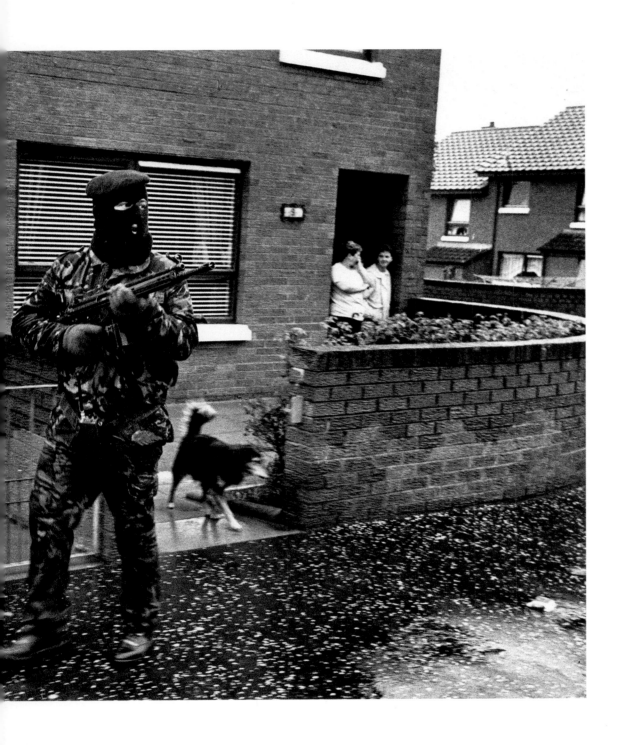

Member of an IRA active service unit patrols the streets of a Nationalist area of Belfast

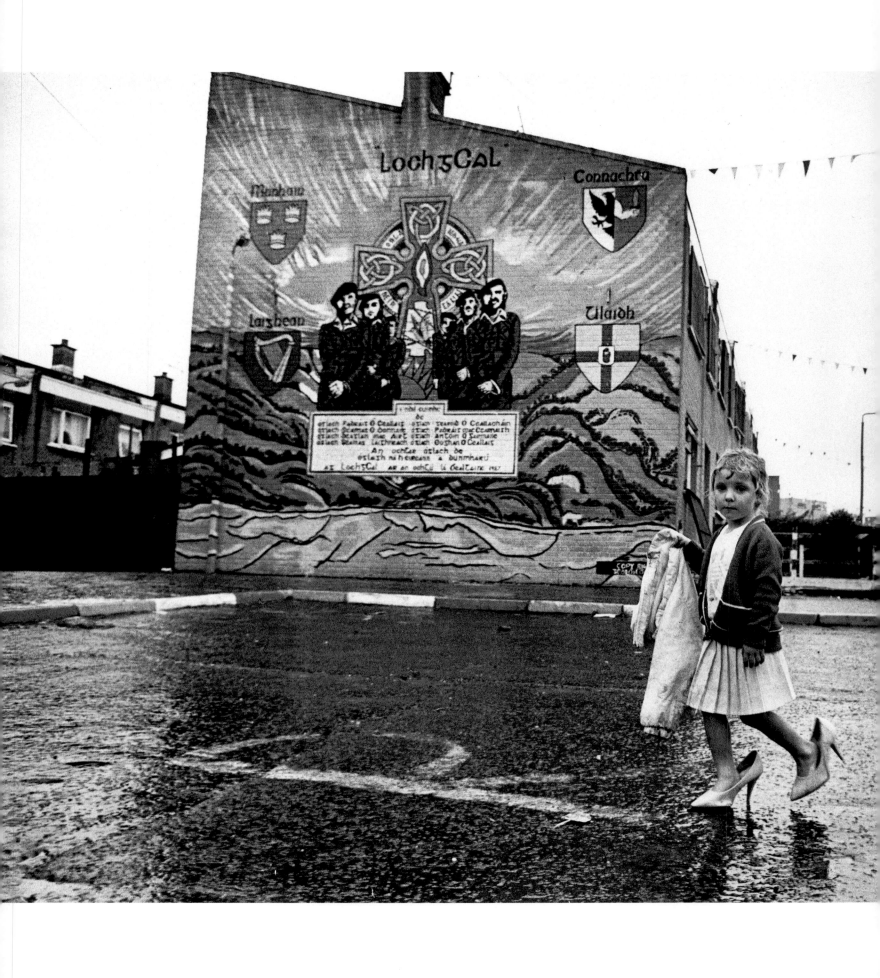

Springhill Estate, Belfast. In the background a mural commemorates the death of 8 IRA men, ambushed while attacking an RUC barracks at Loughgal.

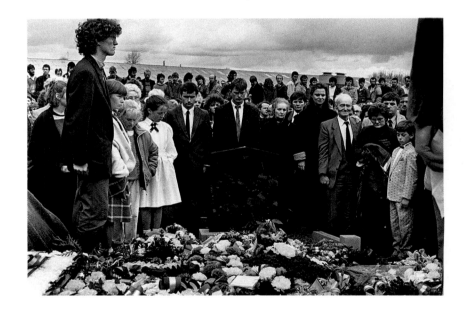

Funeral of IRA volunteer Jim Lynagh, one of the Loughgal 8.
Lathlurcan, County Monaghan, 13 May 1987

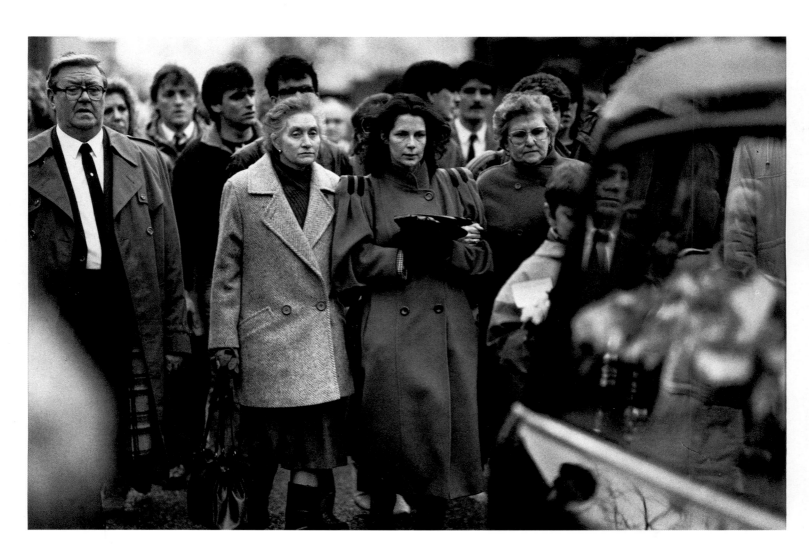

Margaret McCann, widow of IRA volunteer Dan McCann (killed by the SAS in Gibraltar 6 March 1988), carries his beret and gloves, Belfast, 16 March 1988

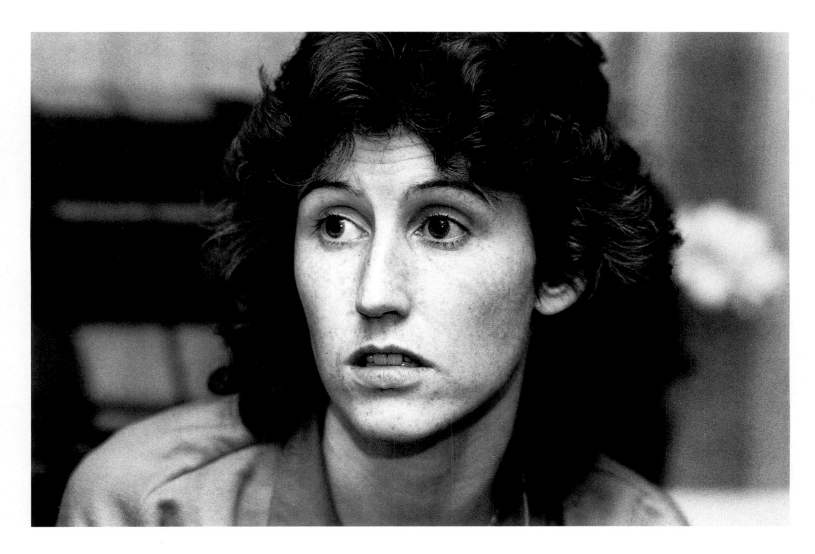

Mairead Farrell on her release from Maghaberry women's prison, 19 September 1986

I'm oppressed as a woman, but I'm also oppressed because I'm Irish. Everyone in this country is oppressed and we can't successfully end our oppression as women until we first end the oppression of our country. But I don't think that's the end of it. It happened before when women took the back seat. But women today have gone through too much, no way will they allow that to happen, and I hope I'm alive because I certainly won't allow that to happen. Women are going to be actively involved to ensure that what happened after 1916 doesn't happen again. Once we remove the British that isn't it. That's only the beginning . . . You have to be realistic. You realise that ultimately you're either going to be dead or end up in jail. It's either one or the other. You're not going to run for ever.

Mairead Farrell, IRA volunteer,
speaking in an interview with Briona McDermott before she was killed
by the SAS in Gibraltar in March 1988.

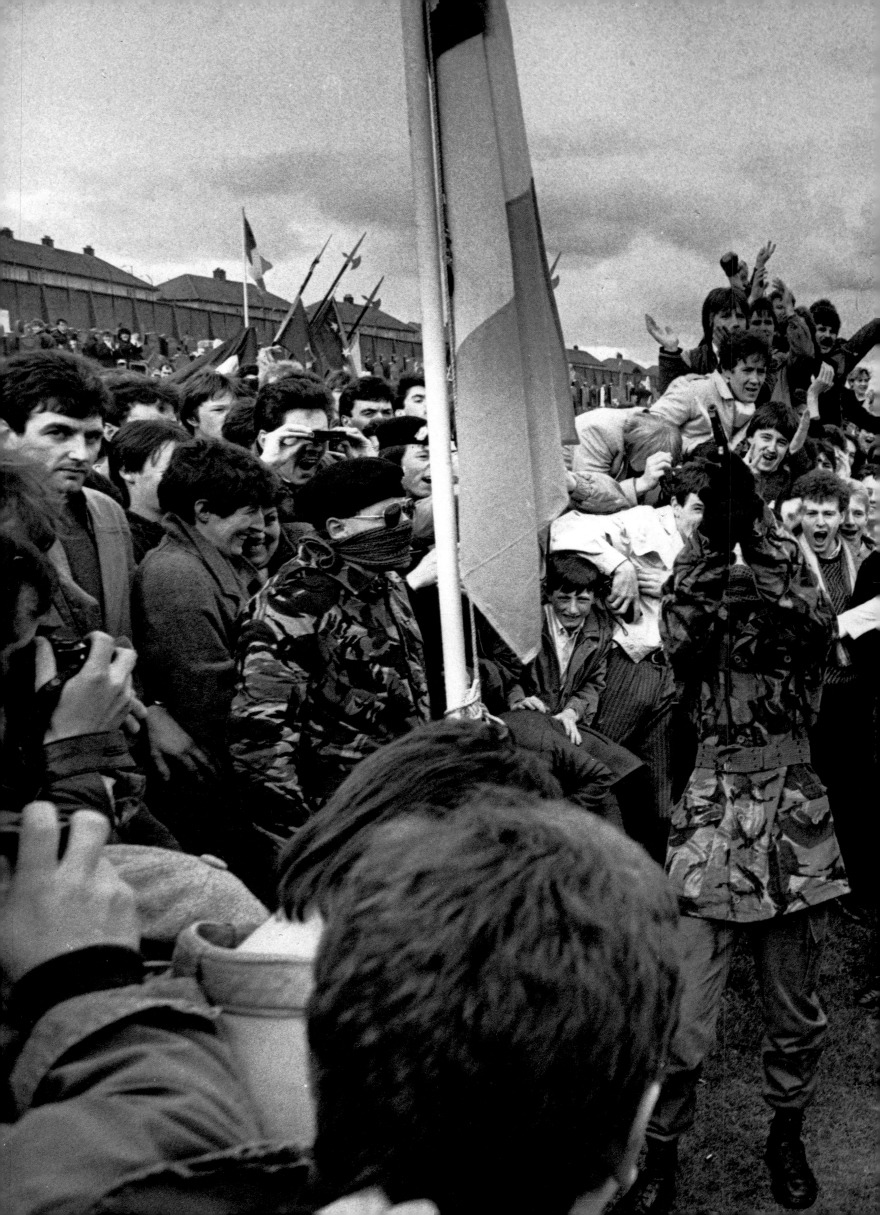

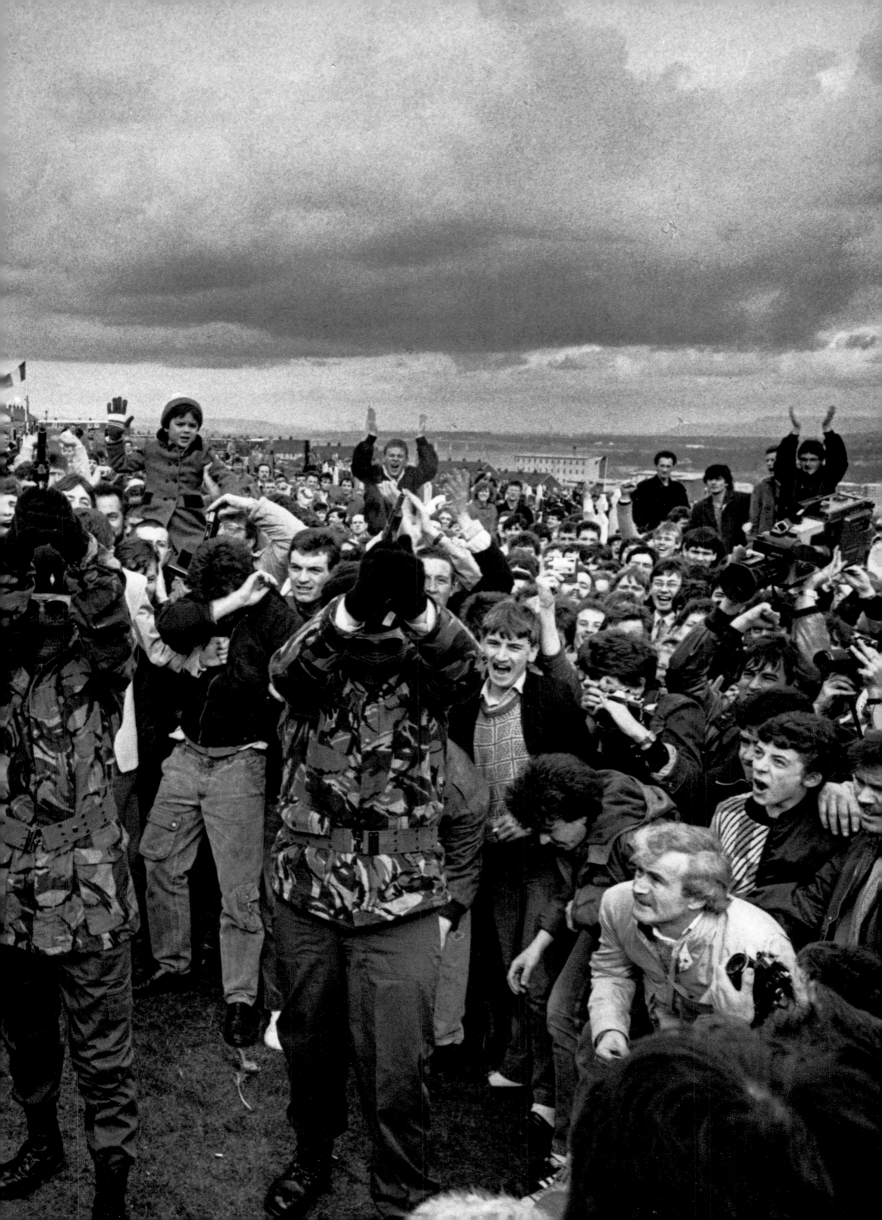

NIGHT

At the corner of Clonard Gardens and the Kashmir Road, a few yards from the laundromat, twenty women had gathered. Some banged bin lids on the pavement, others blew whistles. A sixty-year-old man held an African drum under his arm, and he thumped it with a large spoon. Over the clatter, the drumbeats and the shrieks of the whistles, a friend told me that she had heard the news on Irish radio at 2:00 A.M. Sands had died at 1:17.

I had expected that as soon as Sands died, Clonard and other key districts would be flooded with soldiers. I was wrong; there was not a soldier in sight. People flowed into the street. One man who stood near me wore pyjamas, slippers, a hat and his winter jacket. Several women wore raincoats over nightgowns, and for a while, those wearing slippers outnumbered those wearing shoes.

John Conroy, *War as a Way of Life, a Belfast Diary*

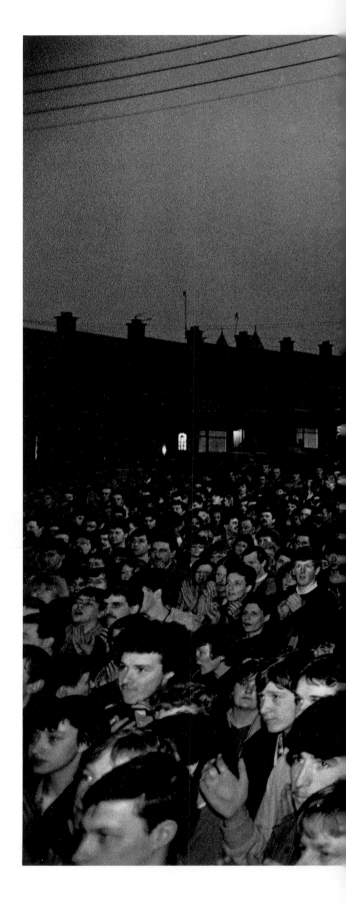

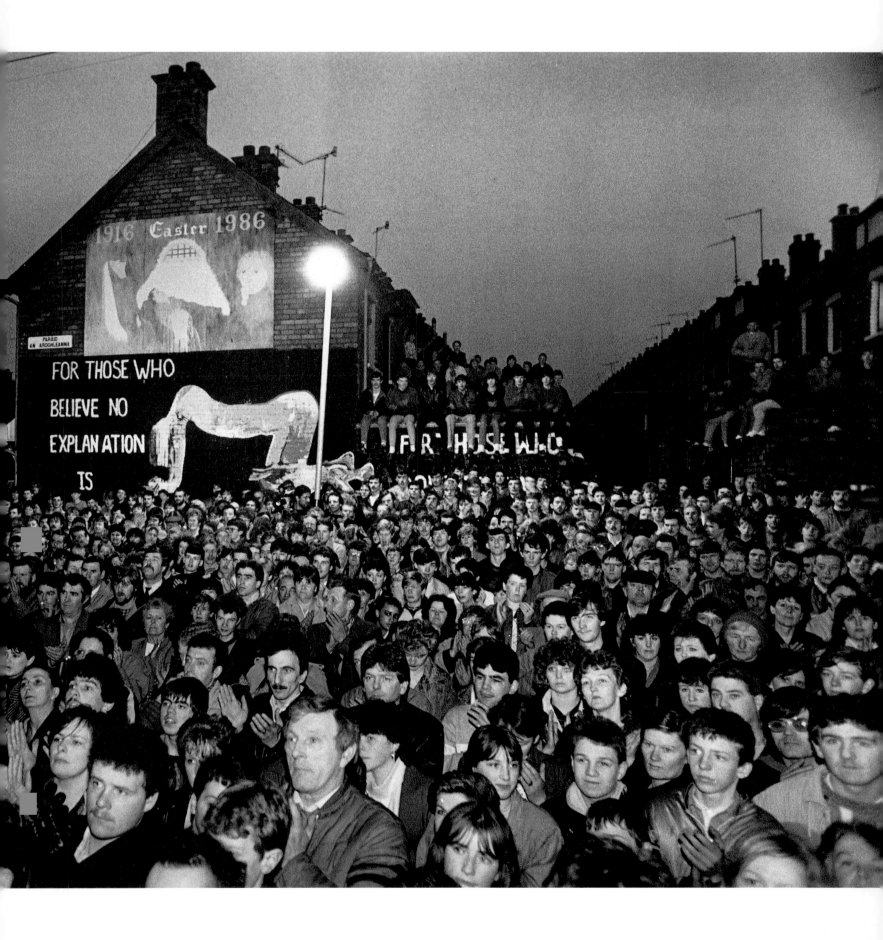

Protest Ardoyne, against policing of the funeral of IRA volunteer Larry Marley

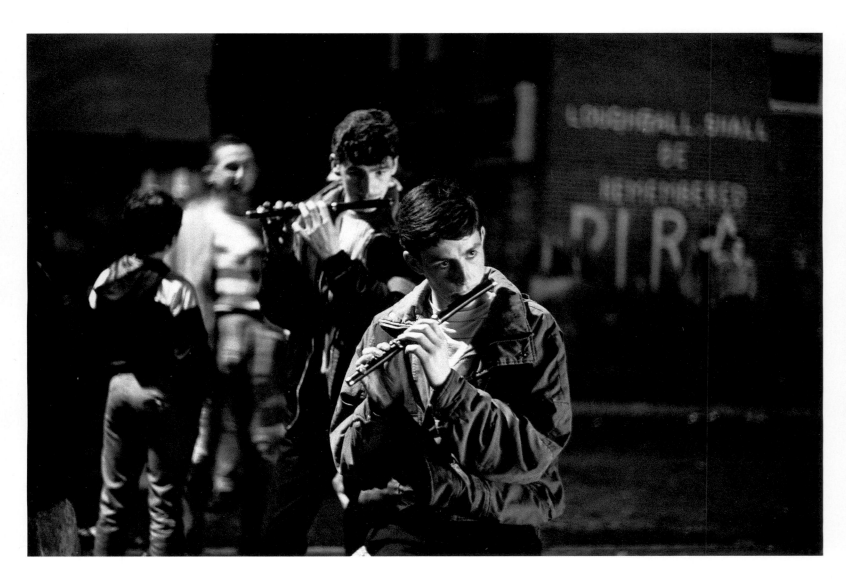

Open-air flute practice, evening, West Belfast

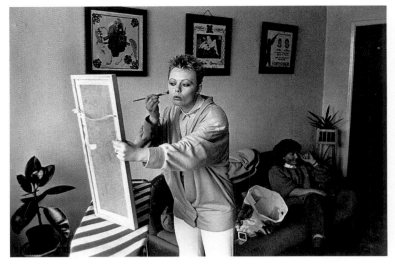

Creggan, Derry

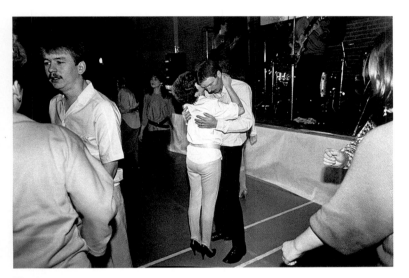

The Shamrock, Ardoyne

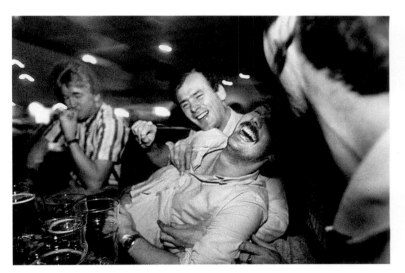

Stag night, Ardoyne

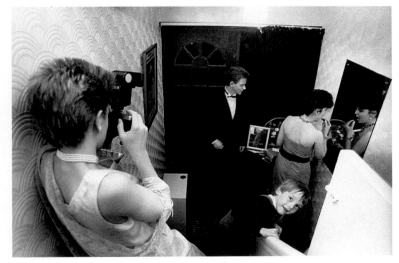

Before the sixth-form social, Belfast

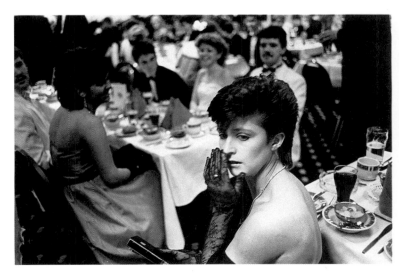

A big night out, Belfast

When my dad was young, the bonfire was lit on the fifteenth of August, the Feast of our Lady. It was the same all over Ireland. But in 1971 there was no bonfire, everyone was out on the streets fighting. The Brits had introduced Internment, and it didn't seem important. The following year was the same – no bonfire – but in 1973 the people began to build them again. But this time it was earlier, for the ninth, and now most Belfast people don't even know that the bonfires came from a religious tradition – they just remember 1971.

Kieran, extract from an interview on Internment night,
Falls Road, 1987

Watching the bonfire, West Belfast, 9 August 1988

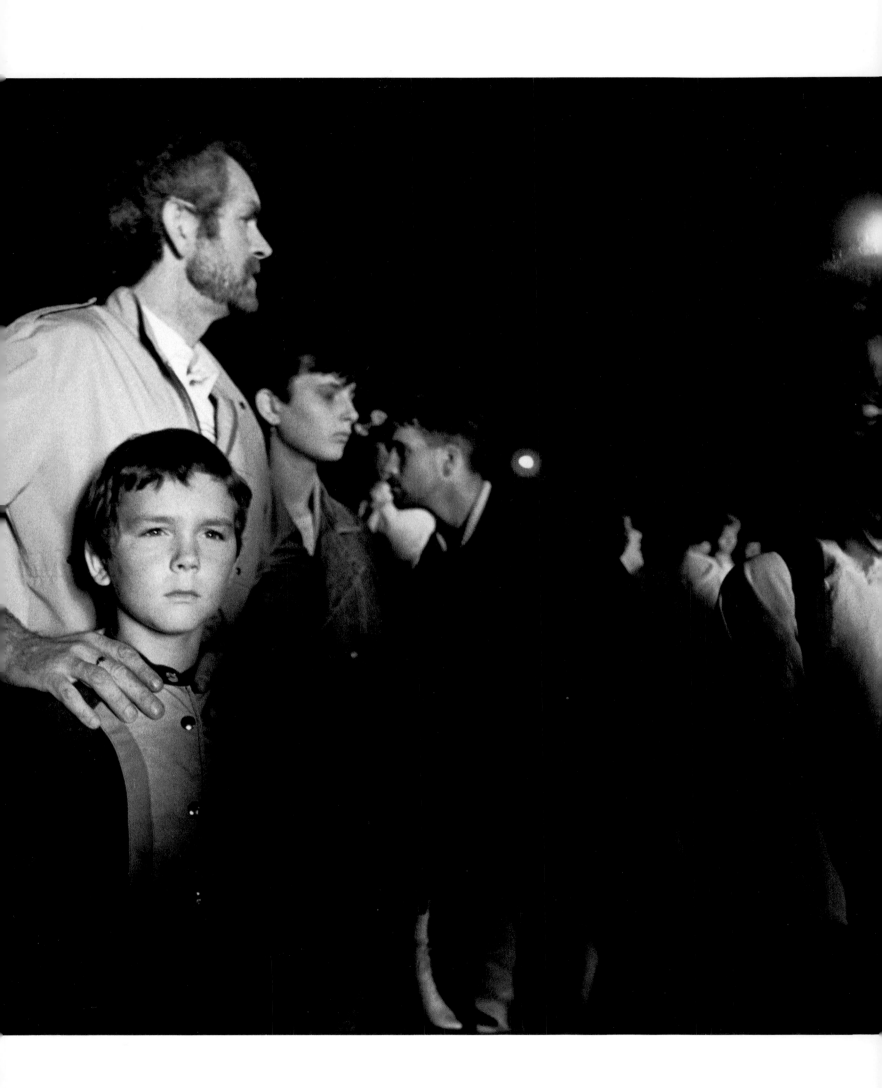

DEATH

I felt nothing but admiration for these people. I couldn't get over how many came out at such short notice. To me, these people gave me heart, gave me strength, I knew they were with me. I didn't want any trouble because I knew there were women, old people and children out there. I said to myself 'something is bound to happen', for the RUC were beginning to push and provoke people even before we went outside. I had the full support of my family postponing the funeral. I thought about what the RUC were doing, about what they'd done at so many other funerals, and I thought about how Larry would've reacted. He'd have said, 'That's it, the RUC aren't going to break us' . . . It was *I* who decided *not* the IRA or Sinn Fein. I said 'NO – he's not going out in all this.' In this country you know someone is going to get killed and God knows it's going to happen again. If they could break us they would. They'd just keep walking all over us, trying to take over every coffin, every funeral. So I said, 'Well, if they get away with this they'll get away with more.' So I postponed the funeral.

Kathleen Marley, interview, *Republican News,* April 1987

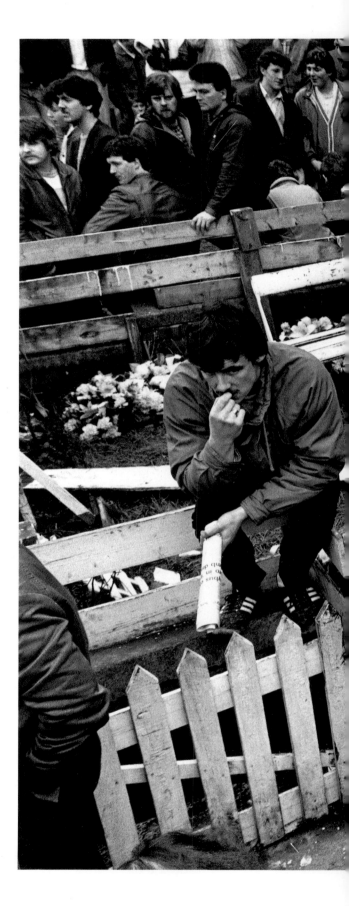

Second day: Garden of the home of IRA volunteer Larry Marley

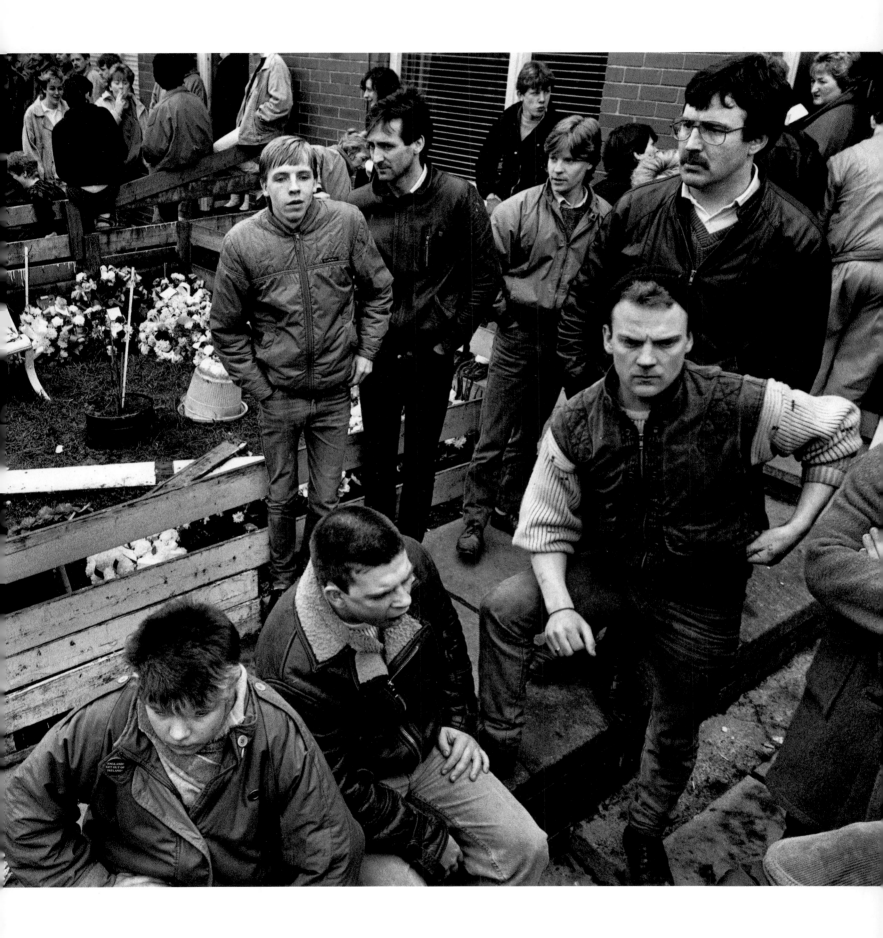

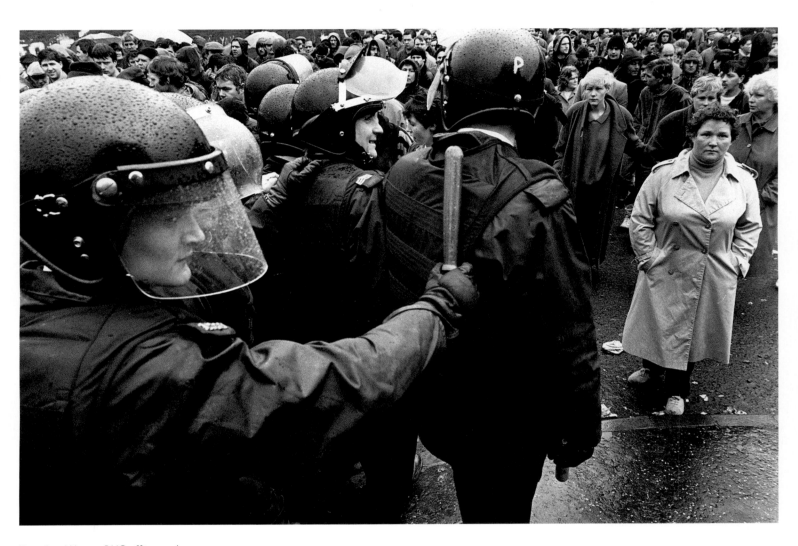

First day: Woman RUC officer and mourners.
Funeral of Larry Marley, Ardoyne, Belfast, 1987

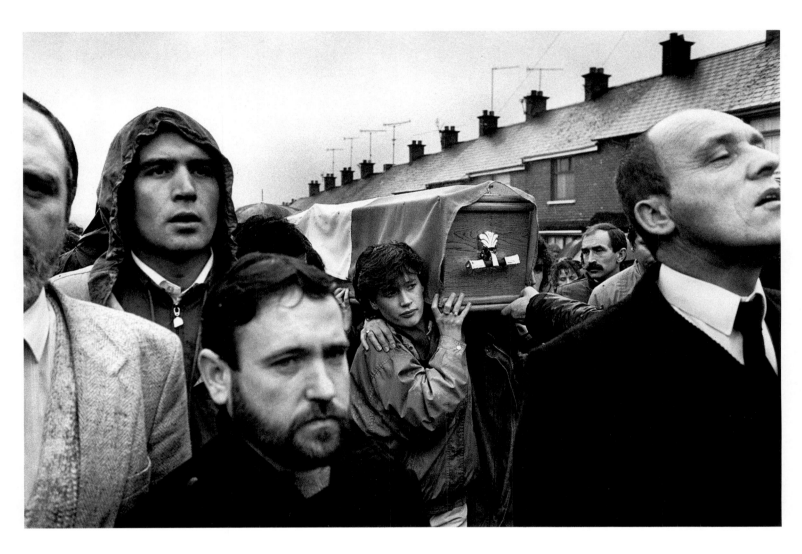

Third day: The coffin eventually leaves the Marley home on its way to Milltown cemetery, Ardoyne, North Belfast

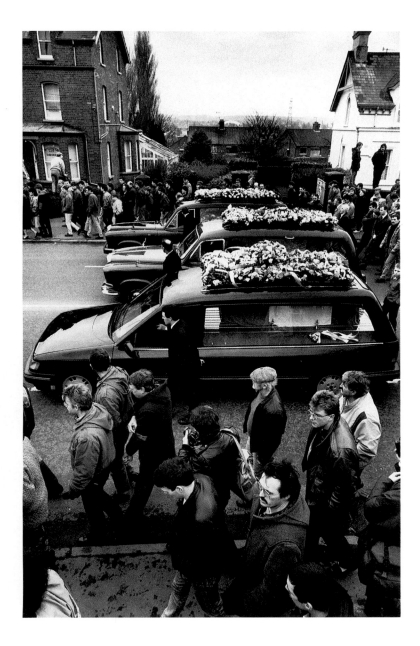

Funeral of Dan McCann, Sean Savage and Mairead Farrell makes its way down the Andersonstown Road to Milltown cemetery, Belfast

Images of March. Images of darkness and of rain. Spring is around the corner but the air reeks of November. All of nature is in mourning, right up to the folds of the grey sky. The earth lies in a veil of crêpe.

They stand like trees, in rows. Erect in the night, still, hands joined or at their side, they grow from the sticky soil, from the rocky paths. Tens, hundreds, thousands of them, all along the road, silent. Whole families, men alone leaning on low stone walls, a woman praying, quiet youths. A few black flags, a few clenched fists. Hardly any tears. Rain drenches their faces. Caught by the headlights of the leading hearse, these figures burst out of the night in ghostly rows, like transient troubled souls.

One night in March, on the road to Drogheda, three black hearses make their way up through Ireland. Dublin to Belfast: not once do they cross empty space. There at the crossroad, here behind a sodden embankment, on the other side of the road, against a wall, under a neon sign, in a pool of darkness, on a hilltop, in a parked car, on the steps of a church, behind a steamed-up pane, people, more and more of them, are watching the passage of the three pierced by British bullets: Mairead, Daniel, Sean, laid out in their wooden boxes.

March, but it could just as well have been November. Mairead Farrell but it could have been Jim Lynagh, Kieran Doherty, Bobby Sands, Terence McSwiney. Individuals with the same cause. The same endless cortège, on the same roads, in the same darkness. In the fields, on the dirt tracks, through the towns, farmers and townsfolk watch the same funeral procession go by.

March, but it could have been yesterday. Troubled images of the past, the fury of fighting, the din of the battle, choked sobs, a glimpse of past sorrows. The silence of the famine, the prayer of a mother evicted from the farm. Rustling noises as the thatch is ripped from the roof. Men at arms watching the scene, leaning on their rifles, standing in the mud in their foreign boots. Bodies crushed in the hold as the ship sails for America. Anger of the dispossessed. Rebellions, rebellions, more rebellions crushed as many times.

'Twenty years ago', we are told. Before that, nothing. One morning just like that, at dawn. Troubles. Out of nothing, starting on very little, like some outburst of anger which no one could have forecast. Unpredictable troubles. A black-and-white explosion along rows of red-brick walls, smokey alleyways, wet footpaths littered with fish-and-chip wrappers. One year of 'troubles', then ten, and now twenty, and the same silent crowd watches the same disfigured bodies. Let this crowd stand there, let it take root in the night, at the road side, at the crossroad, because more young disfigured bodies are on the way, and more mothers and fathers and brothers. And on the other side too, with other crowds drenched by rain and tears. As long as the rustling of the thatch is heard as it is ripped from the roof, as long as the rifles break the windows of the small cottages, as long as the empty stares hit against the walls of prison cells.

And all the while, world opinion tries to understand, tries to come to terms. The press will tell of the blood, looking for the best words. It will talk of dead ones, of conflicts of another age. It will talk in shocked tones or congratulate itself at the right moment. It will condemn, express surprise, indignation, issue more pronouncements, whiling away the hours as coffins pass by, reporting on bonfires lit by armies of children remembering past rebellions.

Twenty years, eight hundred years, two hours, an eternity. And still this morning, as yesterday, the same soldier who stands leaning on his rifle explains to the same defiant faces that his presence protects them all from the storms that he himself unleashed.

Images of March. Images of darkness and of rain. Spring is around the corner, but the air reeks of November. All of nature is in mourning, right up to the folds of the grey sky.

Sorj Chalandon, journalist, *Liberation*, Paris

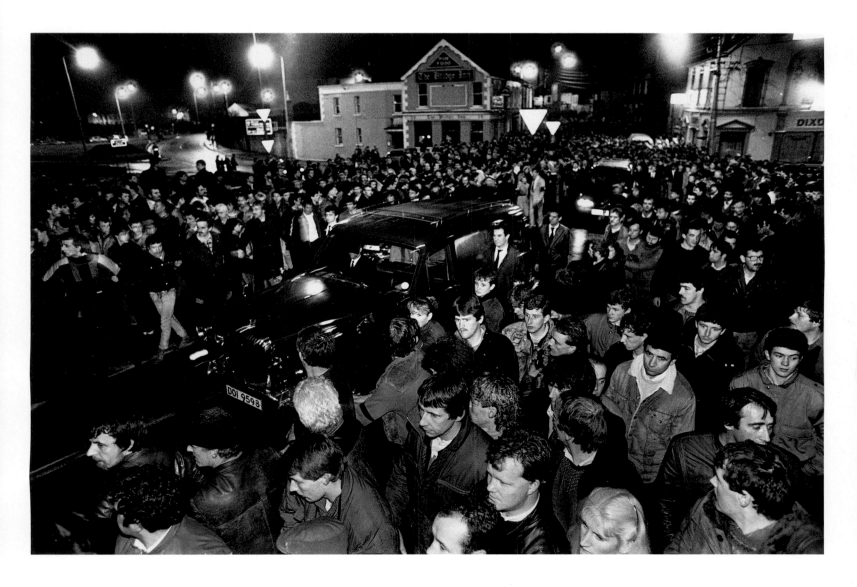

The coffins of the three volunteers killed in Gibraltar are brought home to Belfast from Dublin airport. Thousands of mourners line the hundred-mile route, Dundalk, South of Ireland

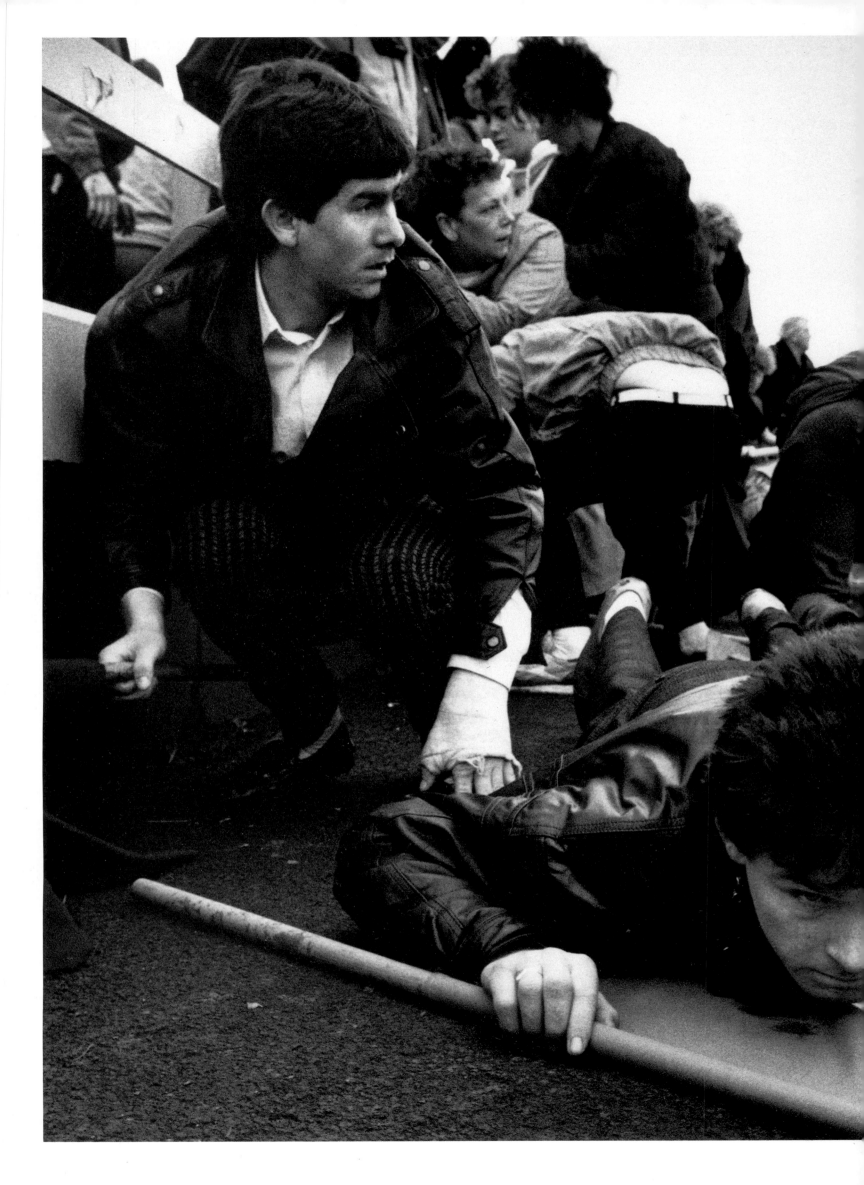

Under fire, mourners take cover at the funeral of the Gibralter 3, Milltown Cemetery, Belfast

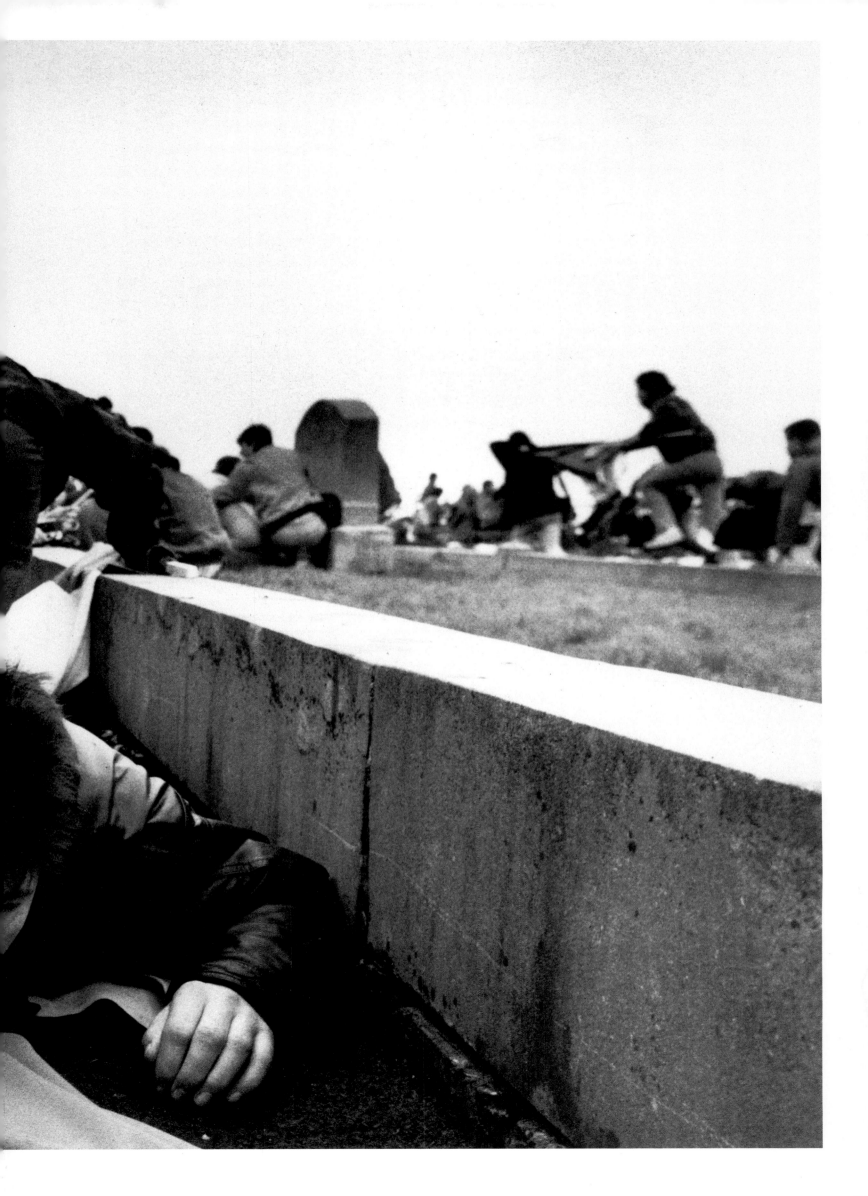

BORDER

Some people have a romantic notion of the countryside and think about waking up to the dawn chorus of the birds and maybe even bees – not in South Armagh. It's the rattle and clatter of the choppers which waken us . . . The helicopters, the bases, the cameras, the lights, all mean that our people must be the most spied upon rural community anywhere in the world, not excluding the German border. It is possible to drive around South Armagh for over an hour without doubling back and never be out of sight of a camera or an outpost for more than a minute or two at a time . . . This must be the most illogical frontier in the world as it runs through fields and farms and even houses. One shop outside Crossmaglen has its front doors in the six counties while the shop itself is in the 26 counties, so that no one can deal in that shop without breaking the law.

Jim McAllister, Sinn Fein Councillor, from his address at the Bobby Sands Memorial Lecture, 1989

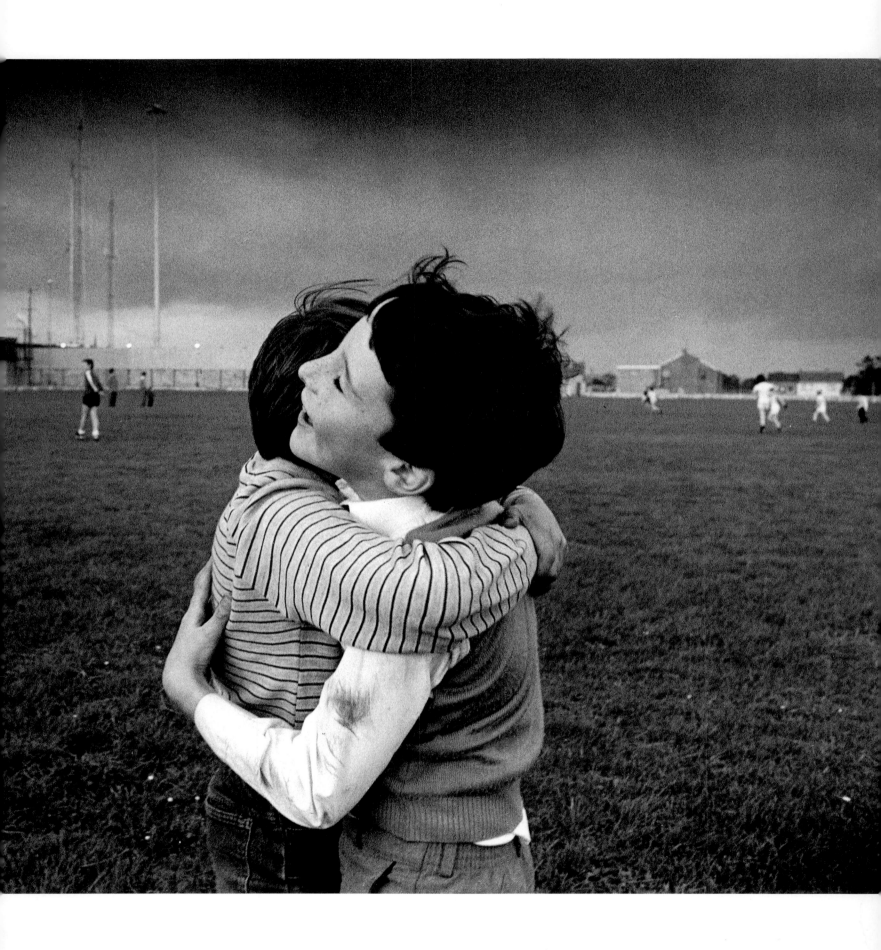

Children playing football in view of the surveillance cameras from the British fort in Crossmaglen

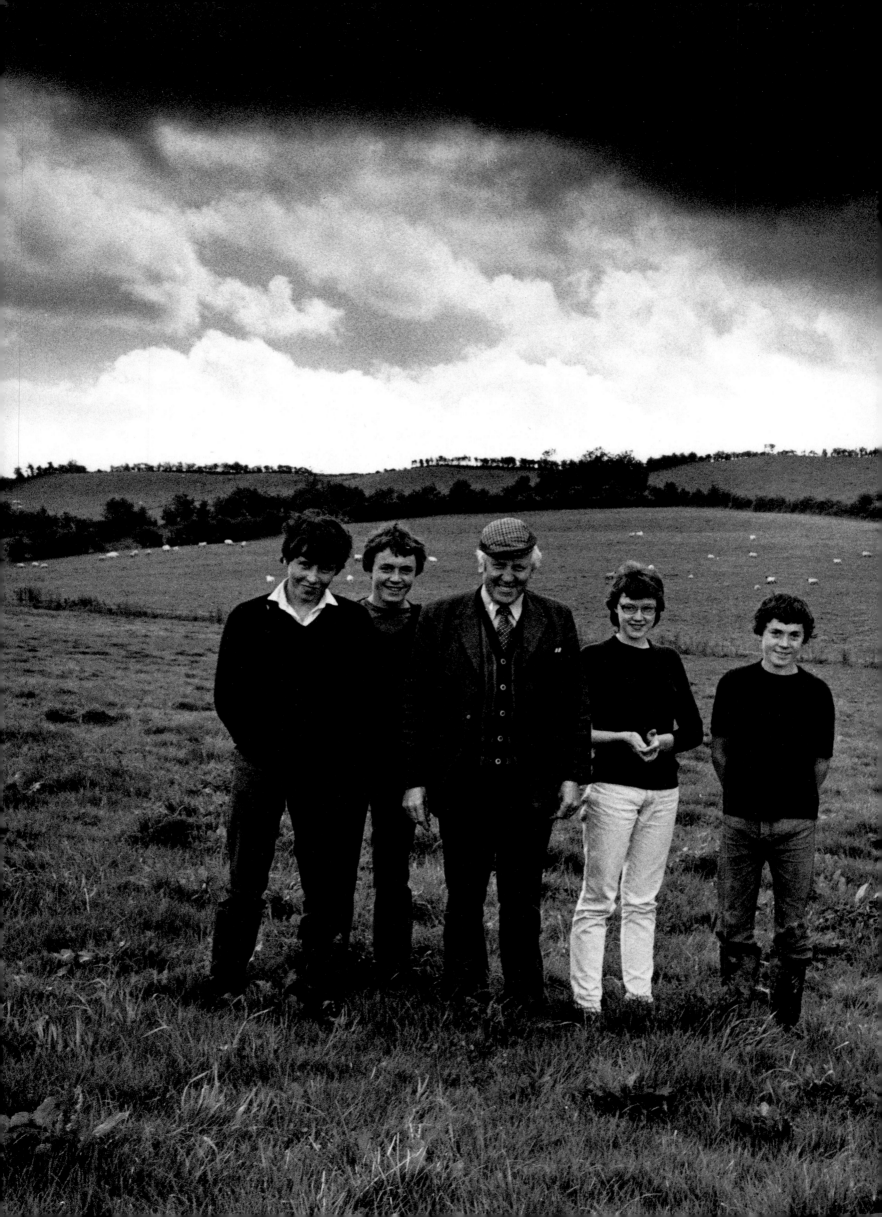

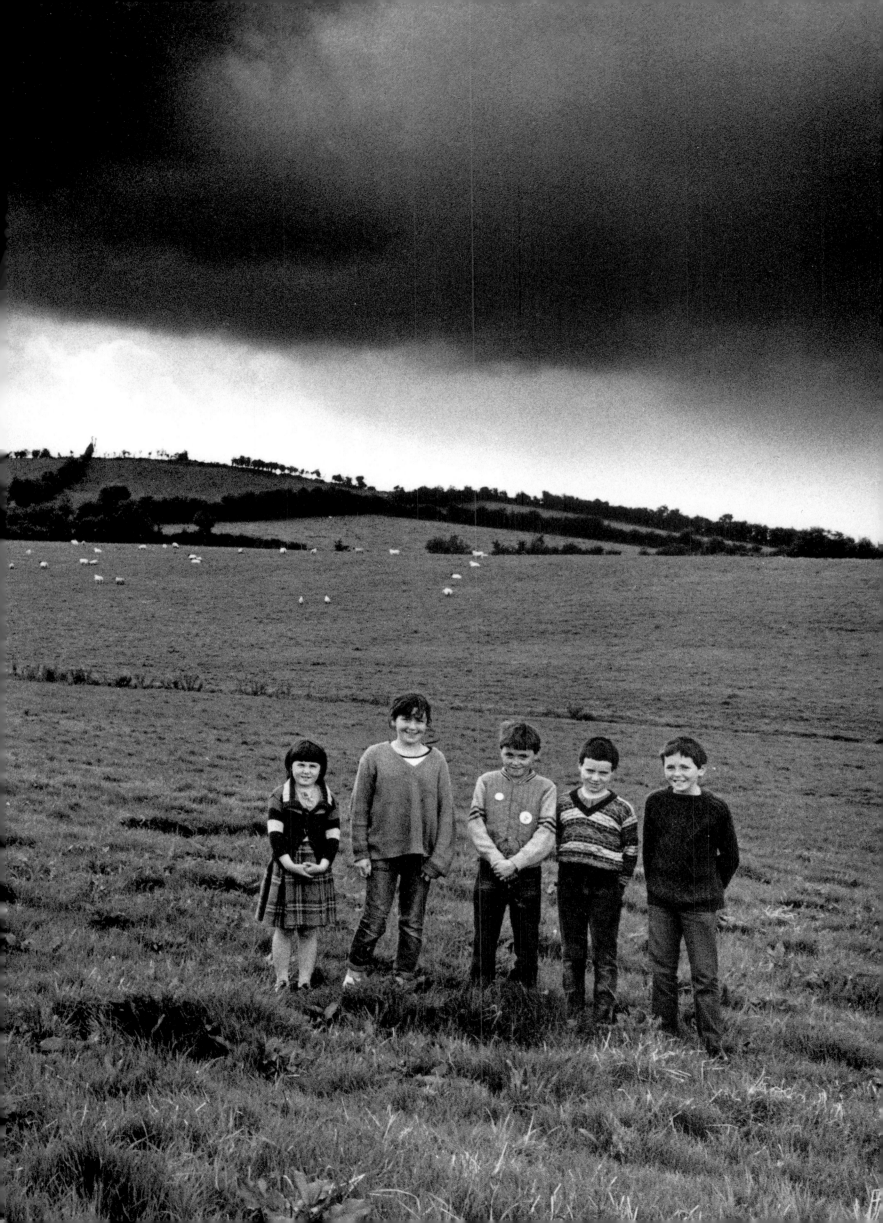

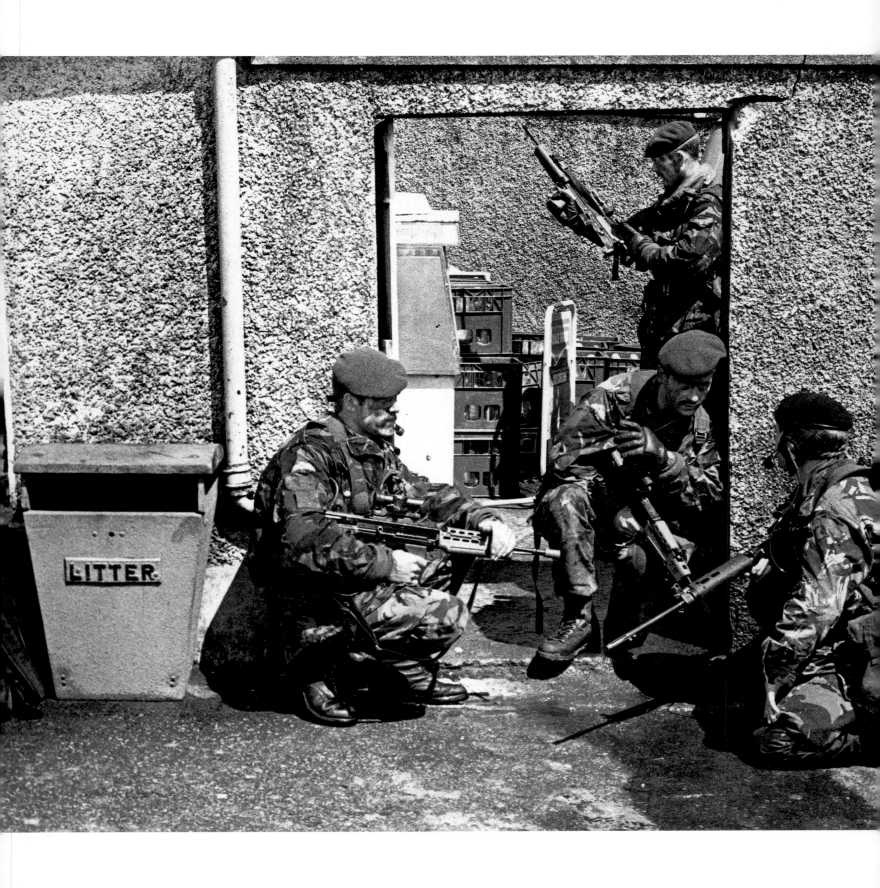

British Army foot patrol, Crossmaglen

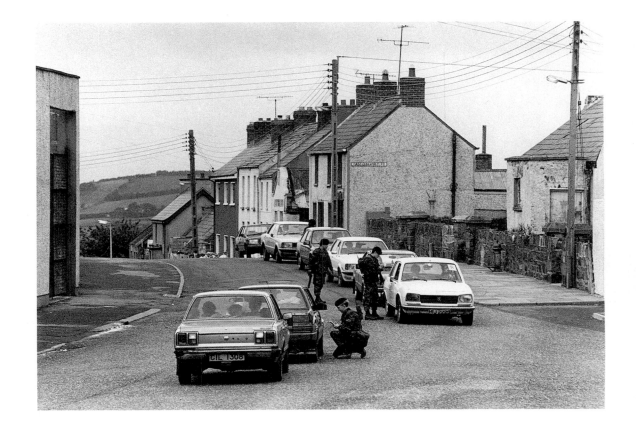

'P. Check', British Army searches cars on the border road out of Crossmaglen

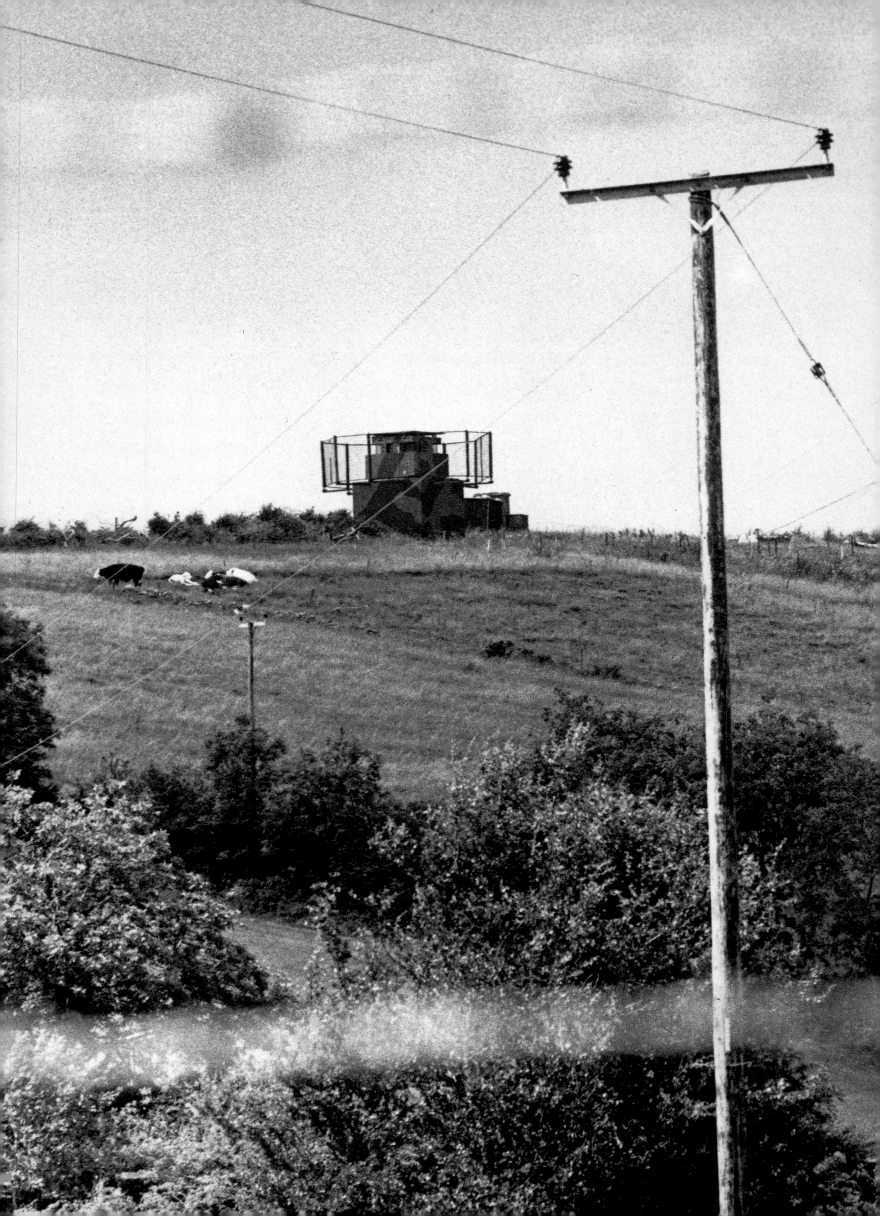

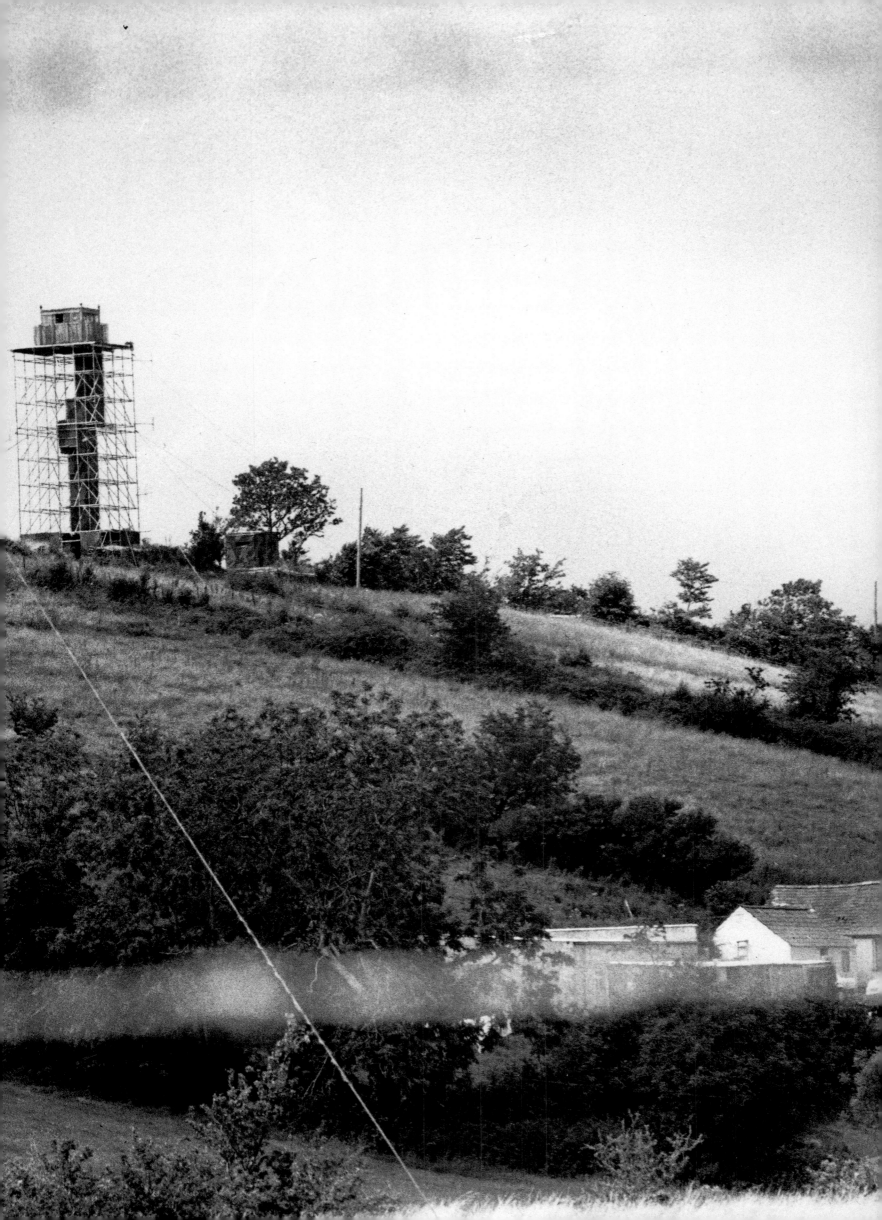

What could be more extreme than to draw an arbitrary line through a country and say that on either side lie foreigners. What could be more extreme than to back up this line with thousands of armed troops. What could be more extreme than for bishops, priests and MPs to call these armed people security forces.

The border is the embodiment of political and military extremism. So extreme are the British and their native allies that they have turned most of South Armagh into what can only be described as an open prison or a reservation. Indeed, the six counties has often been described as an open prison, so South Armagh must be the boards of the top security wing.

Jim McAllister, Sinn Fein Councillor

Country road in Ireland . . . border between two states, South Armagh

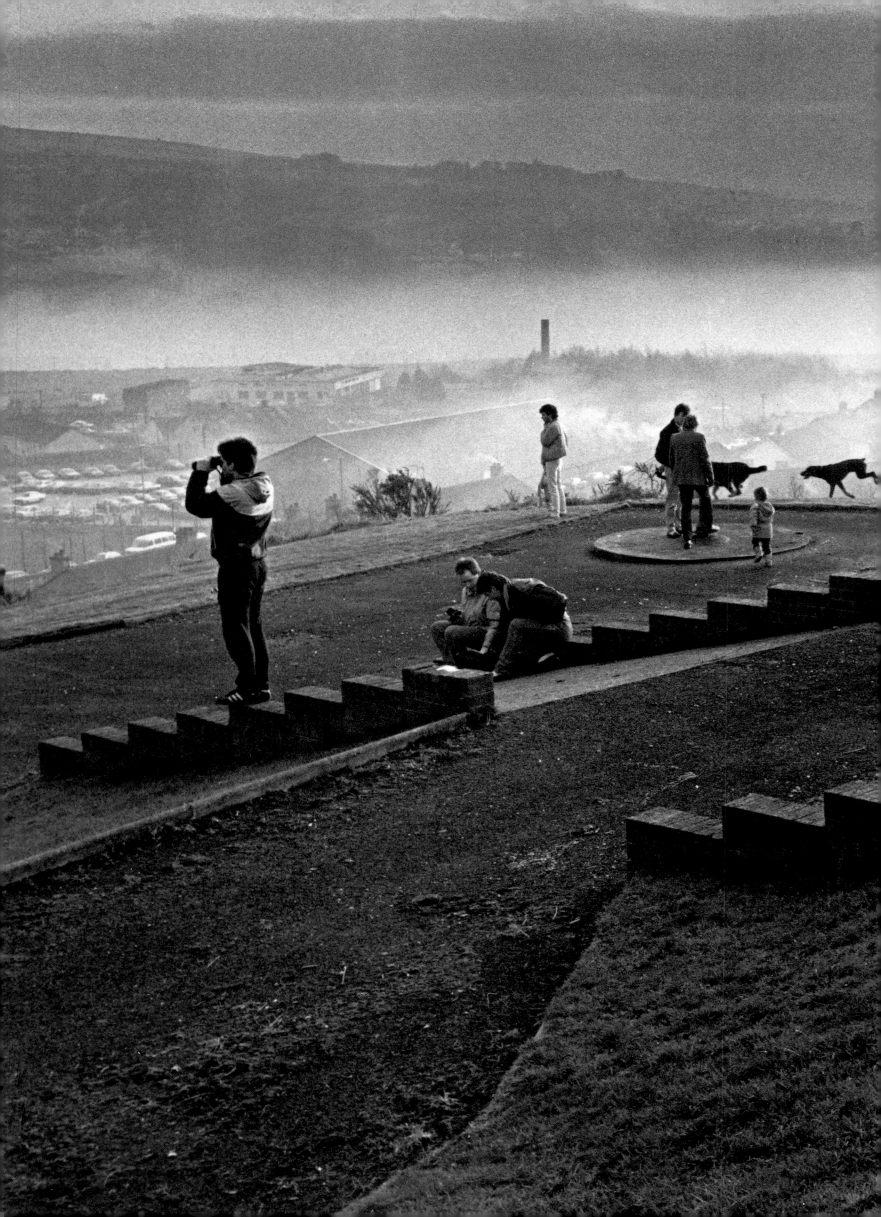

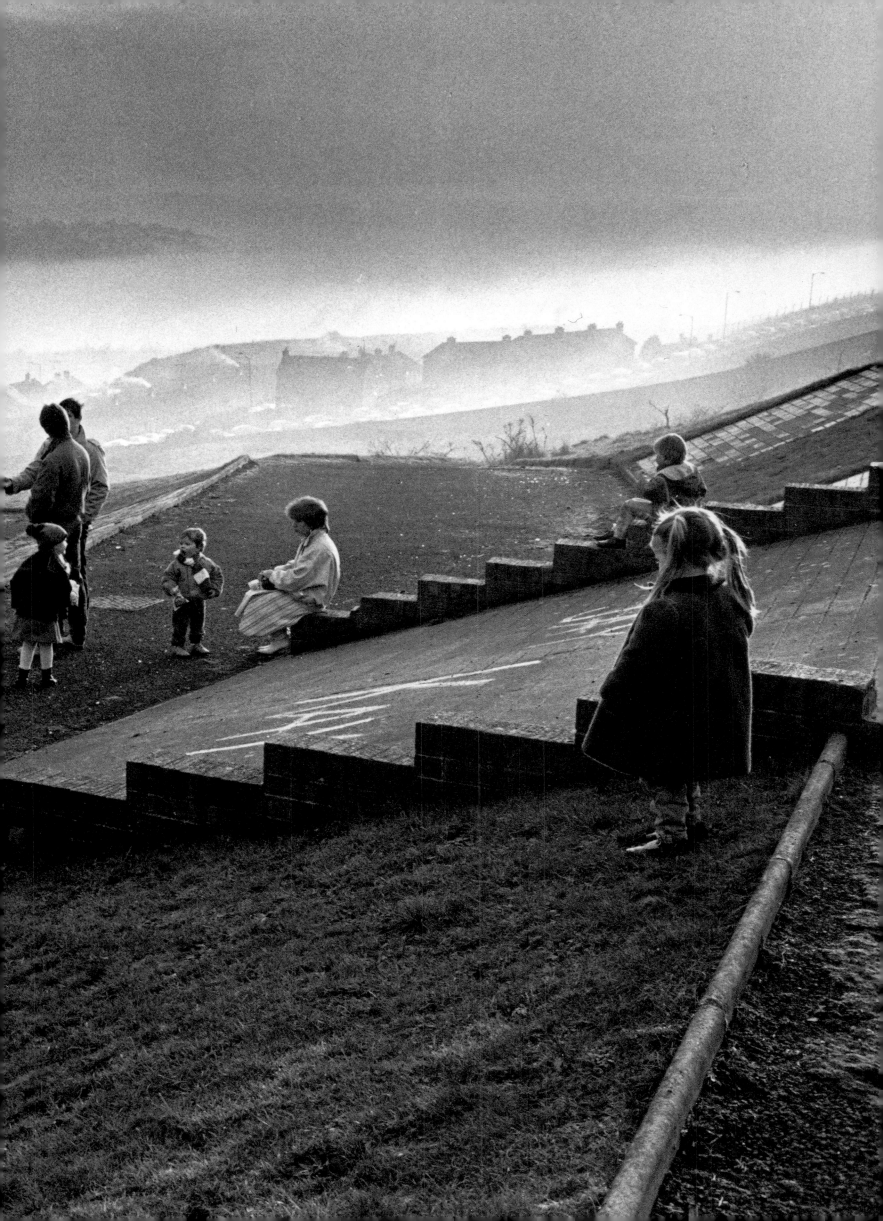

Photographs by Mike Abrahams: pages 2, 6-7, 8, 9, 12, 16-17, 22-23, 24, 25, 26, 27 (below), 28-29, 30, 31, 34 (below), 35, 38, 39, 40-41, 42, 43, 46-47, 51, 52-53, 55, 60-61, 64-65, 66, 67, 68 (above), 69, 76 (above, below/right), 77 (above, below/right), 78, 79, 86, 96, 97, 100-101, 103 (above/both), 106-107, 108, 109, 110, 111, 112-113, 114, 115-116, 117, 118-119, 121, 125.

Photographs by Laurie Sparham: cover, pages 11, 14-15, 18, 20-21, 27 (above), 32-33, 34 (above), 36-37, 44-45, 48-49, 50 (both), 54, 56-57, 58 (both), 59 (both), 62-63, 68 (below), 70-71, 72-73, 74-75, 76 (below/left), 77 (below/left), 80-81, 82-83, 84-85, 87, 88-89, 90, 91, 92-93, 94, 95, 98-99, 102, 103 (below/both), 104-105, 120, 122-123, 126-127, 128.

1967 – January: Northern Ireland Civil Rights Association set up, demanding 'one man, one vote' in local elections and an end to discrimination in jobs and housing.

1968 – 5 October: RUC baton civil rights march in Derry.

1969 – January: Civil rights marchers attacked at Burntollet by Loyalists. RUC stand by. RUC reserves run amok in Derry. Civil rights activist Bernadette Devlin elected MP for Mid-Ulster. July/August: Three Nationalists die following RUC beatings, the first deaths of the 'troubles'. Battle of the Bogside. 9-year-old Patrick Rooney is shot dead in his bed by RUC in Divis flats. First child to be killed in this phase of troubles. British troops brought on to the streets.

1970 – Counter-insurgency expert Brigadier Frank Kitson sent to command British Army. 3 people shot dead during 34-hour curfew of the Lower Falls.

1971 – August: Internment is reintroduced, hundreds detained, 17 people die during a period of 36 hours. European Court of Human Rights finds Britain guilty of 'inhuman and degrading treatment' of internees.

1972 – 30 January: Bloody Sunday. British paratroopers shoot dead 14 men (7 of whom are under 19) during anti-Internment rally. March: Stormont collapses, replaced by direct rule from Westminster. June: 30-day hunger-strike by Republicans in Crumlin Road gaol wins de facto political status. July: RAF flies Republican leaders, including Gerry Adams and Martin McGuinness, to London for secret talks with the British Government. July: Operation Motorman, British Army dismantles 'no-go' areas of Belfast and Derry. Westminster approves introduction of no-jury 'Diplock' courts.

1973 – March: First IRA bombings in London. December: Sunningdale conference agrees to a Council of Ireland.

1974 – May: Loyalist general strike leads to collapse of 4-month-old 'power-sharing' Executive. Prevention of Terrorism Act passed, allowing people to be held for 7 days without charge.

1975 – 10-month truce between IRA and British Government.

1976 – March: Special Category Status is withdrawn from prisoners. Republicans refuse to wear prison uniform and go 'on the blanket'.

1977 – Government report says the infant mortality rate in the North of Ireland is the highest in the UK and among the highest in the EEC. Unemployment reaches 13% (over 60,000), the highest locally since 1938. In Britain the figure was 6.8%. Mason announces more undercover operations and increases in RUC and UDR numbers.

1978 – Trade unionist Brian Maguire found hanging in his cell at Castlereagh interrogation centre. Amnesty International report finds consistent evidence of maltreatment of suspects by RUC and calls for public inquiry. De Lorean car project announced.

1979 – National 'H' Block/Armagh Committee set up to campaign for the restoration of political status. Local police surgeon and official, quoted in the Bennett report, confirms serious injury to people in RUC detention.

1980 – Belfast Welfare Rights poverty survey shows that Northern Ireland is the poorest region of UK. First hunger-strike, by Republican prisoners in Long Kesh and Armagh.

1981 – March-October: 10 Republican prisoners die on hunger-strike in 'H' Blocks, Long Kesh. Bobby Sands is elected MP for Fermanagh/South Tyrone. Two other hunger-strikers are elected to the Southern Parliament. Belfast Nationalist Christopher Black is arrested by the RUC and becomes the first paid informer.

1982 – October: Sinn Fein wins 5 seats to new Assembley. De Lorean car factory closes; almost 80 million in public funds has been lost in the venture.

1983 – June: Gerry Adams elected MP, Sinn Fein candidate for West Belfast. 38 IRA prisoners escape from the 'H' Blocks. In an evident change of tactics, RUC begin to stage massive presence at Republican funerals and seek to control arrangements.

1984 – Loyalist politician George Seawright says Catholics and their priests should be incinerated. Margaret Thatcher narrowly escapes death when IRA bomb Grand Hotel, Brighton, during Conservative Party Conference.

1985 – May: Sinn Fein wins 59 seats in local council elections. Anglo-Irish Agreement signed, Hillsborough Castle, Loyalists begin large-scale protest campaign against proposed Dublin involvement.

1986 – Aquittals of 42 defendants in the Christopher Black 'supergrass' appeals. Manchester Deputy Chief Constable John Stalker removed from inquiry into deaths of 6 unarmed Nationalists in 1982. He was considering recommending charges against top RUC officers.

1987 – April: Confrontations at Republican funerals, including that of Lawrence Marley. 8 IRA members killed in SAS ambush at Loughall. Gerry Adams maintains his seat.

1988 – March: IRA members Mairead Farrell, Dan McCann and Sean Savage shot dead at Gibraltar. At their funeral, Loyalist gunmen attack mourners at Milltown cemetery, killing 3 men. Three days later, 2 British soldiers drive into funeral of one of the victims and are shot by the IRA. October: British government bans broadcast interviews with Sinn Fein and the IRA.

1989 – Spate of sectarian assassinations of Nationalists. May: Sinn Fein achieves 11.3% of the vote in local government elections, coming second in Belfast.

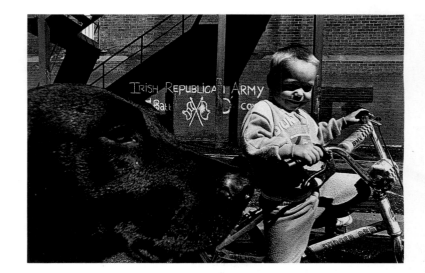